對 虛 像 的 偏 愛

田 川 弘 ＰＹＧＭＡＬＩＯＮ 女 性 人 物 模 型 作 品 集

田川弘

Introduction

「究竟要如何才能達到田川大師的塗裝境界？」不只人物模型初學者，這是大家心中的疑問。對此田川弘的回答是：完美塗裝所需的運筆和細膩植毛等技巧，除了實際動手累積經驗之外別無他法，這就是最快的捷徑。至於要如何「表現」，就只能觀察各種事物，並且增加從中感知的機會。例如：觀看電影、欣賞戲劇、外出散步、與親友話家常。再者，大家是否能感受日常生活中的一切事務，好比夕陽的美好、路邊的小花、泥土的芬芳、人群的喧囂，並且將這些感受儲存成內在的能量，在細細品味後轉化成創作表現。相信透過這本田川弘的作品集，大家都能從中找到答案。

Many people aspire to become master figure painters like Hiroshi Tagawa. Tagawa's unmatched brush-stroke precision is not something you can master in a day. There is no shortcut in acquiring essential figure painting techniques. There is no other way but to actualy work with your hands and gain experience.

However, its a whole different story when it comes to figure's expression. Her suddle smile, relaxed posture, a hint of shyness in her facial expression...... these are something you can output to your figure by experiencing first hand. Tagawa emphasizes the importance of going outside for a walk, watching movies, and talking with friends and families to accurately represent feelings and emotions to otherwise lifeless sculptures. He wishes this book would give novice figure painters insight into how to digest information from daily lives and output to their works.

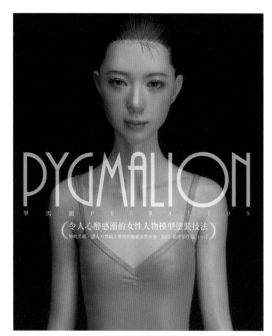

田川弘身為人物模型塗裝師，除了日本國內，還擁有許多國外的粉絲。這本書透過照片搭配文字，詳盡說明了肌膚最後修飾的方法……等田川弘至今累積的塗裝技巧，充滿塗裝大師田川弘對於人物模型的哲學概念，是粉絲必須擁有的經典藏書。

PYGMAION令人心醉惑溺的女性人物模型塗裝技法
ISBN 9789579559607
96頁 定價480元
北星圖書事業股份有限公司出版（繁中版）

"PYGMALION," named after a legendary king and sculptor in Greek mythology, is Tagawa's first book, which explains his techniques in detail alongside close-up photos and interviews. This book, filled with Tagawa's philosophy and passion, is a must-have for all his fans in and outside Japan.

INDEX

田川 弘

Profile

1959年出生於宮崎縣，畢業於大分縣立藝術短期大學附設綠丘高等學校（美術班），之後就讀名古屋藝術大學繪畫科（西洋繪畫），立志成為平面創作者。1988～1993年榮獲中日展「大賞」和「佳作賞」（名古屋市博物館），然而在1995年接觸了林浩己原型的擬真人物模型後，於1996年開始嘗試女性擬真人物模型塗裝。其後於2011年正式以人物模型塗裝師為職志從事各項活動，並舉辦各項個展，甚至風靡無數國外粉絲，成為擬真人物模型塗裝大師。

Born in Miyazaki Prefecture in 1959, Tagawa graduated from Midorigaoka High School, attached to Oita Prefectural College of Arts and Culture, and entered the Nagoya University of Arts, Department of Painting (Western painting). From 1988 to 1993, He won a "grand prize" as well as an "honorable mentions award" for the Chunichi Exhibition (Nagoya City Museum). In 1995, Tagawa encountered the world of figure sculptures when he was exposed to Hiroki Hayashi's works and painted his first realistic female figure in 1996. In 2011, he started his career as a full-fledged figure painter. Since then, he has held many solo exhibitions and became a famed professional figure painter with many fans in Japan and worldwide.

前 言
Preamble

有一種創作屬於模型文學。

何謂文學,我想關於這個提問大家心中都有各自的答案。而其中一個答案就是作者透過故事表達自己本身。

因此透過『心』我們最終討論的是夏目漱石,藉由『發條鳥年代記』我們談論的是村上春樹,經由『風起』我們感受的是堀辰雄和宮崎駿。

沒錯!文學並不只存在於文學作品之中。『新世紀福音戰士』蘊含了庵野秀明的文學,『機動警察劇場版2』呈現了押井守的文學,而『塗鴉日記』屬於東村明子的文學。

近年新的文學作品銷售困難,有種無力推廣的感覺。這是因為大眾早已能從各種管道汲取文學的養分。Twitter就有『小熊蛋糕店』的假面凸文學,也有川尻小玉文學。

而模型當然也可稱作一種文學,透過作品流露出創作者的個性,屬於作者的故事。

當然每件作品都可看到創作者的影子,但總覺得不夠完整。若能觀賞所有作品並且閱讀創作者的文字,就能更貼近創作者的內心,而作品集就是最佳途徑。

橫山宏的作品集充滿「模型樂趣」的能量波動,而高石誠的『戰車模型超級技術指南』則散發著修行者般的嚴謹,每次翻閱都讓人感受到那份認真與執著。我將這些流露作者個性的模型書籍稱為「模型文學書」。

接著讓我們來談談田川弘的作品集。

在第一本著作『PYGMAION令人心醉惑溺的女性人物模型塗裝技法』中,原型師林浩己曾說過,田川弘在塗裝技法方面並沒有超凡卓越的技巧,但是他的作品就是能帶來超越技巧的感動,我想大家透過這本作品集就會有相同的感受。

為何能讓人如此悸動,他只簡單地答道:我只是愛上人物模型而已。

我認識的創作者中,只有他表示提升模型塗裝的方法就是愛上模型?為何會口出此言?而且又是如何做到?如何向一塊樹脂訴說情衷?如何與之相戀?我想這就是文學,除了文學無從解釋。

我們從田川弘作品中感受到的不僅僅是運用油畫顏料的技巧,而是流瀉於技巧之外,對人物模型的愛戀,是創作者本人。當然每件作品中都蘊藏了他的個性。然而將田川弘的作品彙整成冊,更能看出其創作的表現內涵。那就是他對模型的愛慕之情。這是模型文學,你我正在翻頁「閱讀」這本文學鉅作。

流傳後世的模型文學就此誕生。

I believe that there is such a thing as maquette literature. Before describing what maquette literature is, let's answer the big question first......what is literature?

One of the answers is that literature tells about the author through a story. Therefore, it is ultimately the author us readers discuss through their books. It is Soseki Natsume we talk about through "Kokoro," it is Haruki Murakami who speaks through "The Chronicle of the Screwtape Bird." It is Tatsuo Hori and Hayao Miyazaki who we feel the emotion of after watching "The Wind Rises." Of course, literature doesn't need to revolve around texts and words. There is Anno Hideaki's literature in "Evangelion" and Higashimura Akiko's in "Blank Canvas: My So-Called Artist's Journey." People say book sales are declining day by day, but that is no surprise to me. We are exposed to literacy 24/7 through movies, comics, animations, and so on. Thus, I can confidently say that maquette literature exists just like in any other medium. Maquette literature is, in essence, the personality of each creator that exudes through their works.

As Hiroki Hayashi, a renowned figure sculptor, said in Tagawa's first book "PYGMALION," Tagawa is not necessarily the most technically skilled figure painter in the world. However, it is without a doubt that his works strike a chord with many audiences, including the readers of this book. I once asked him, "How do you do it?" and Tagawa calmly replied, "Just fall in love with the figure." It's not just techniques we learn from his works, but his affection, care, predilection, and adoration towards figures. Tagawa's creations and this book are the epitomai of maquette literature

井上純一
Jyunichi Inoue

Profile

1970年出生,為TRPG設計師、漫畫家和玩具公司的社長,還會以希有馬的名字創作。最近因為隨筆漫畫『中國嫁日記』的老公井上而廣為人知。自己本身也是一名模型師,閱讀了田川弘的前一本著作『PYGMAION令人心醉惑溺的女性人物模型塗裝技法』而深受感動。

Born in 1970. Inoue, also known as "Keuma", is a tabletop role-playing game designer, a manga artist, and a toy company president. Recently, he is famously known as "Jin-san," the husband character of the essay cartoon "Diary of a Chinese Wife." Inoue is a modeler himself and remembers the shock he felt when he first saw Tagawa's works in his first book, "PYGMALION."

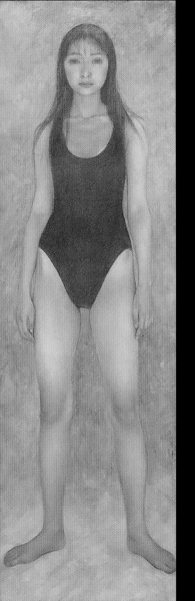

對虛像的偏愛

Obsession with fictional image

你在哪裡出生？身邊有哪些人？過著甚麼樣的人生？會感到開心、寂寞，有無法抑制的憤怒和悲傷。而現在又在想些甚麼？望向何處？我終於看到你的內心，所以我用我的畫筆描繪出你的想法、現在的身影、雙眼凝視的地方……。

塗裝人物模型時，你是否也會投注如此豐沛的情感？宛如鋼琴家在琴鍵上彈出內心湧現的情感，只是指法之精準穩定，交織出一段優美的旋律。田川弘的作品之所以讓人感動，我想就像鋼琴家能用樂器演繹自身情感一般，他不過是能夠用畫筆將內心的感受毫無保留地表現出來。

Where were you born? Who raised you, who took care of you? Who were your friends? What kind of life did you live? Happy, lonely, rage beyond control, utter sadness, I wonder how you are feeling now. Where are you headed? Ah, there you are...... I finally found you-don't worry. I will use my brush to express your thoughts, your inside and outside, and beyond what your eyes see......

These are the thoughts master figure painter has in his mind. Not many people can put this much emotion into otherwise lifeless resin figures. It's as if he is a pianist who outputs his inner emotions onto the keyboard, filled with passion yet with unmatched precision. This is why Tagawa's works move people's hearts. The figures he paints are filled with his thoughts and feelings. For a pianist, a piano is his/her instrument.....but for Tagawa, a paint brush is.

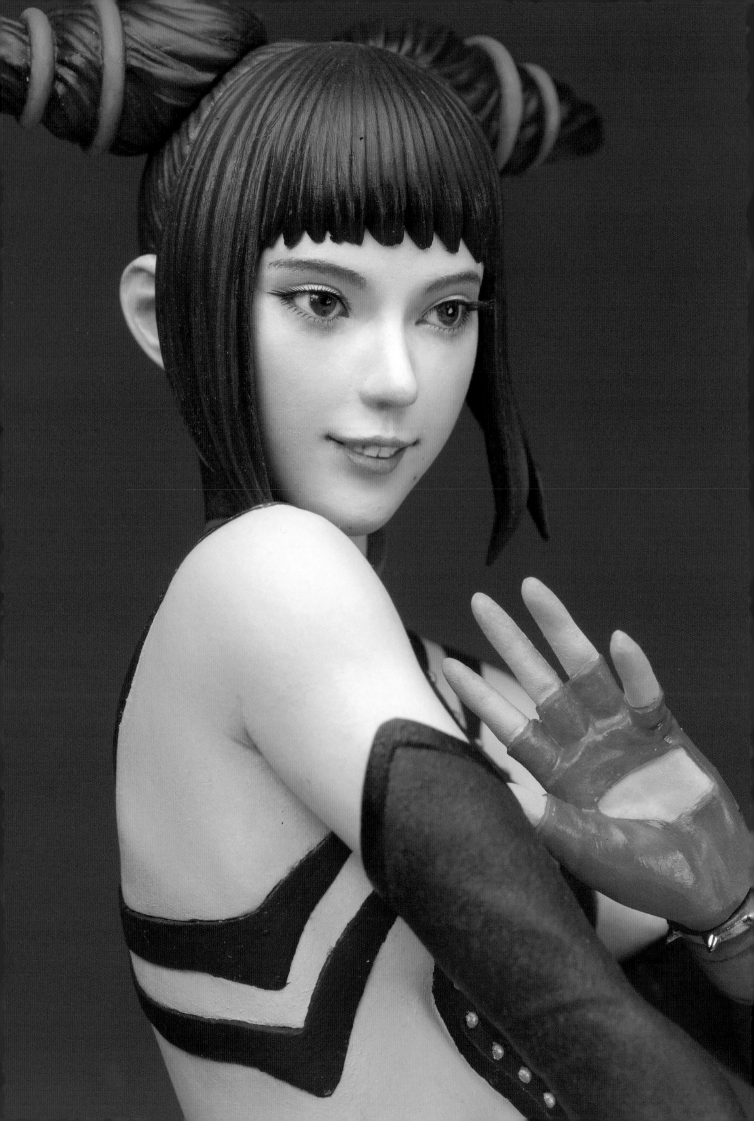

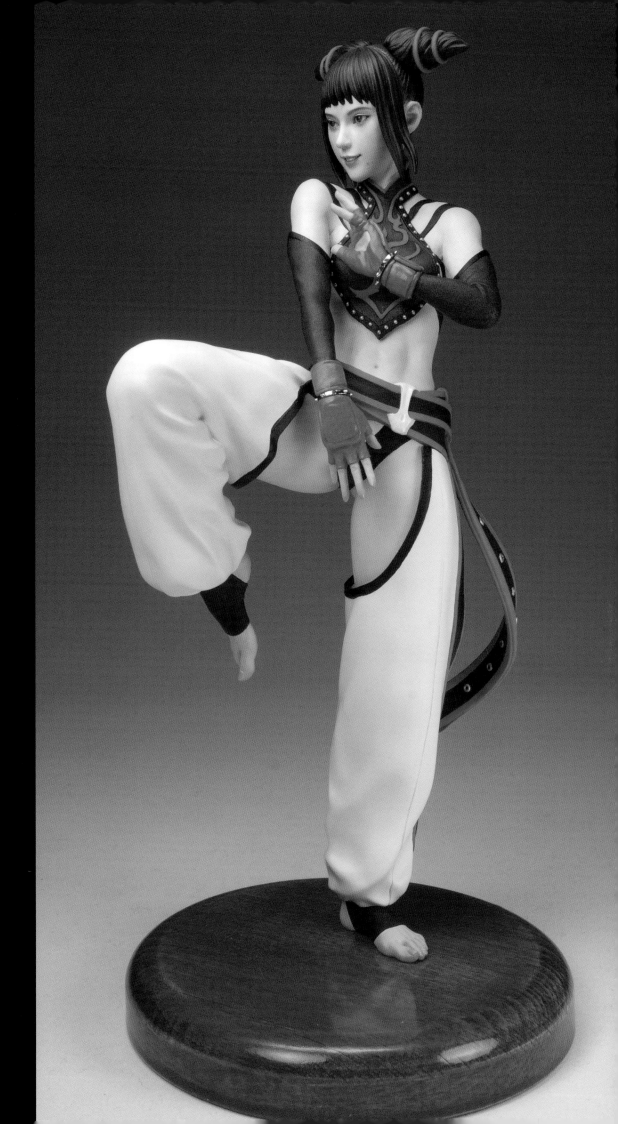

韓蛛俐 2 號機
Han Juri 2

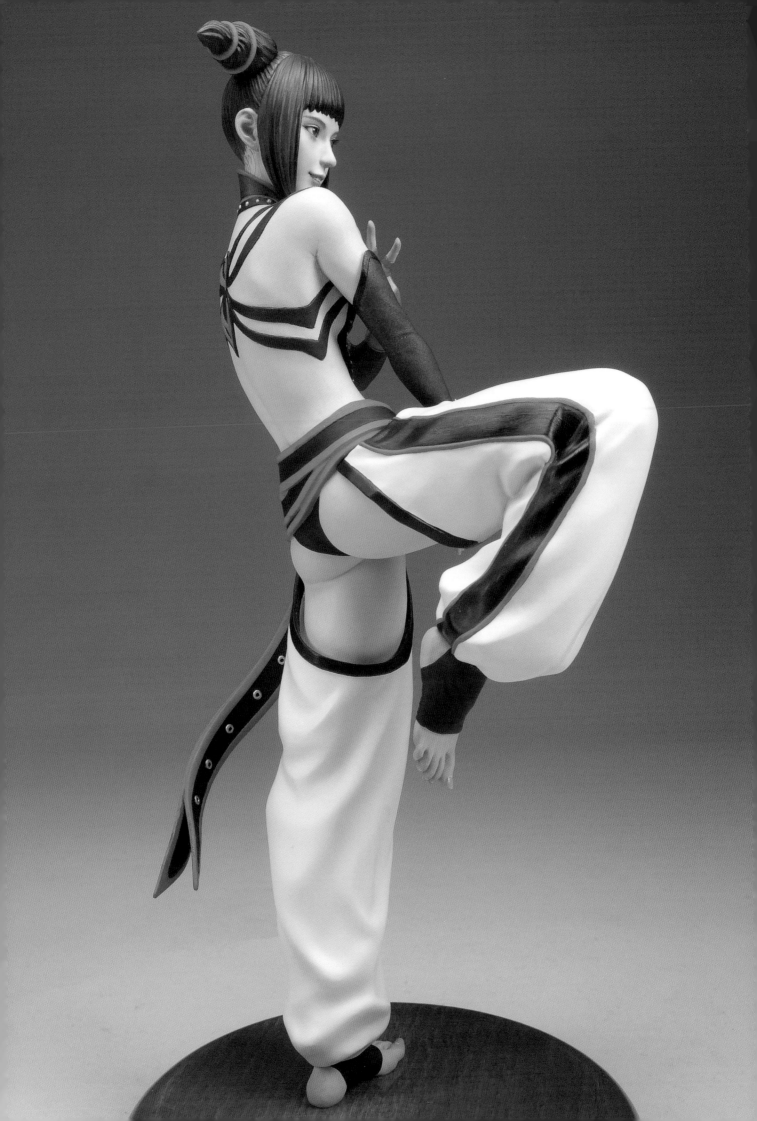

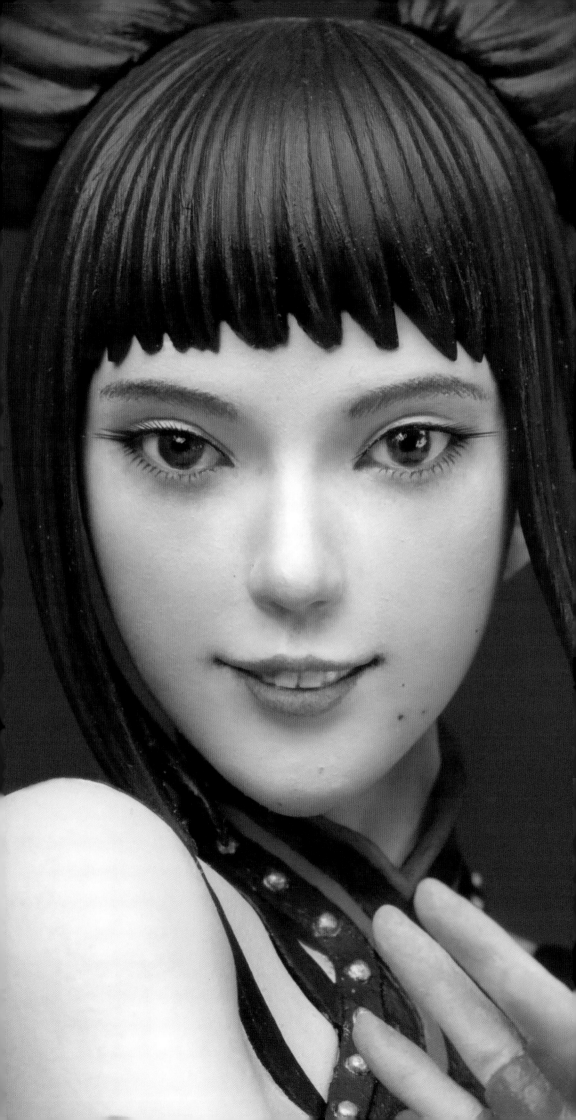

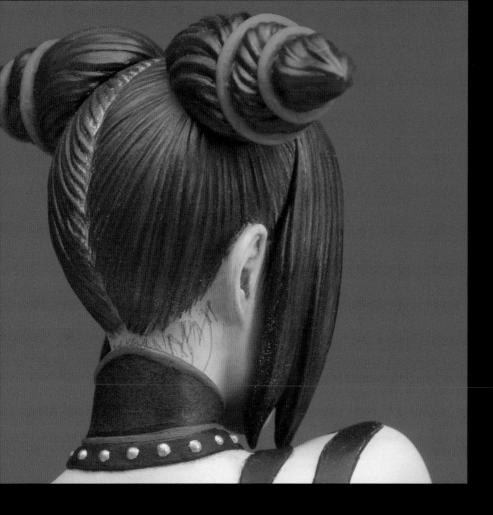

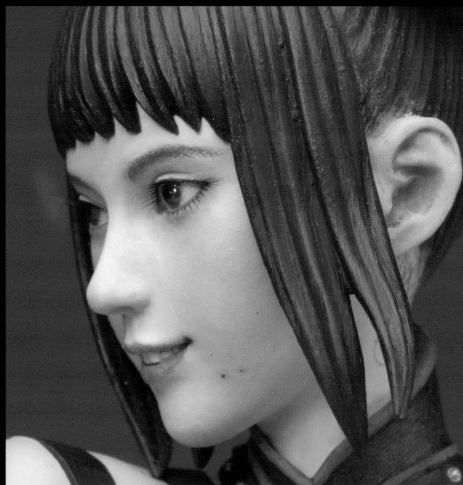

韓蛛俐 2 號機
Han Juri 2

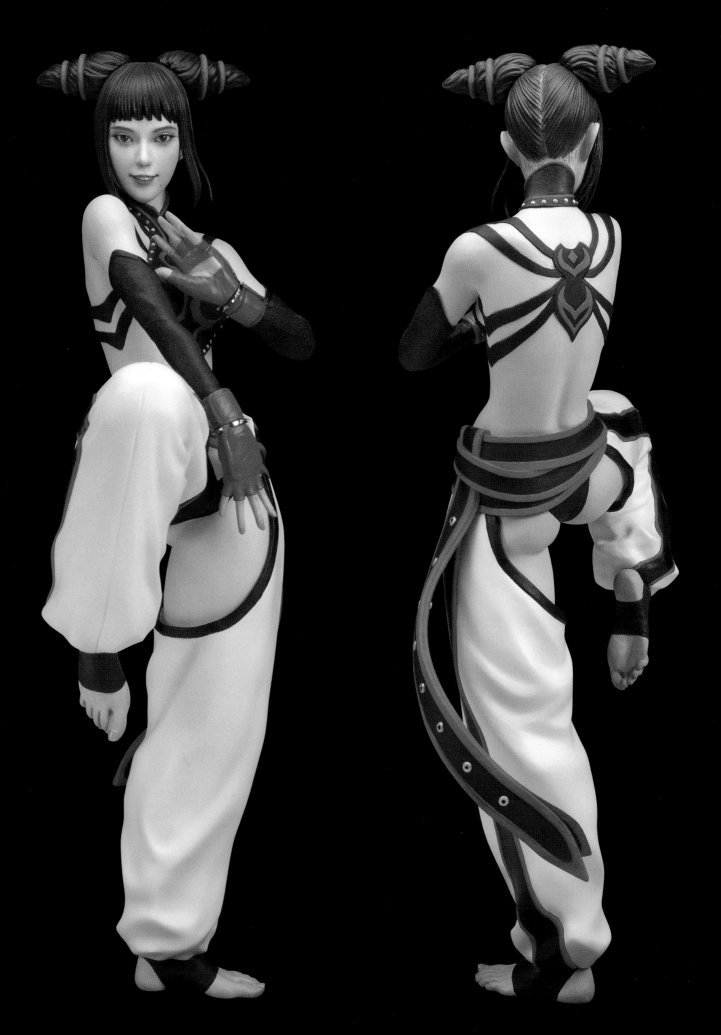

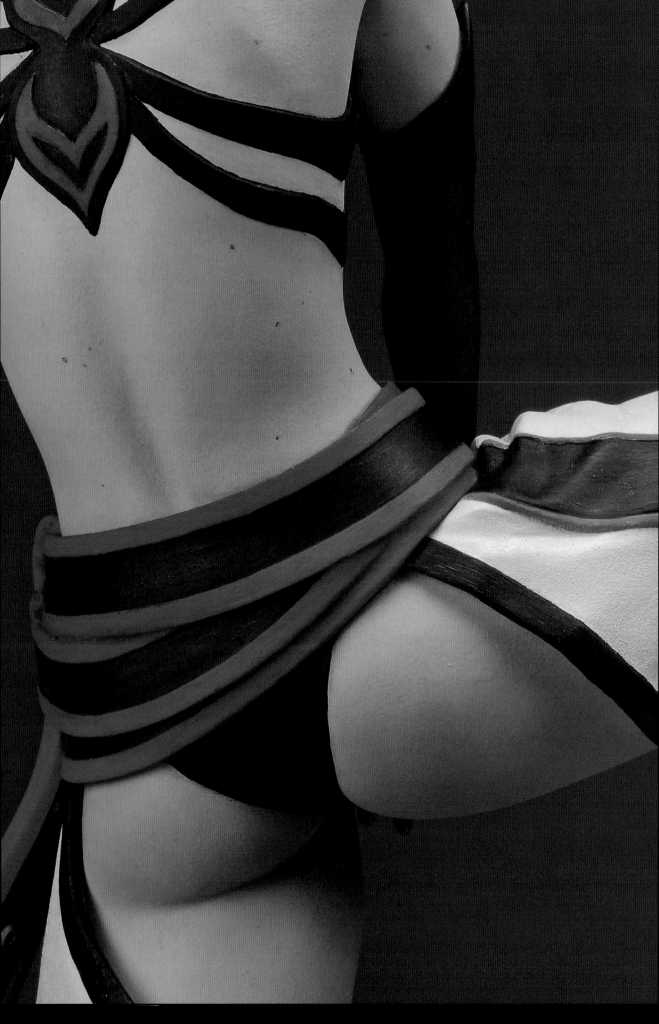

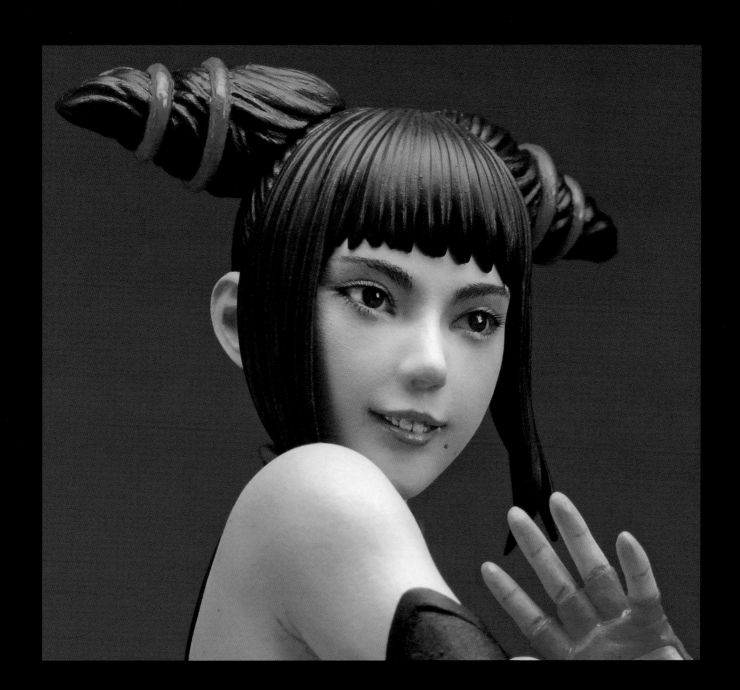

韓蛛俐 1 號機
Han Juri 1

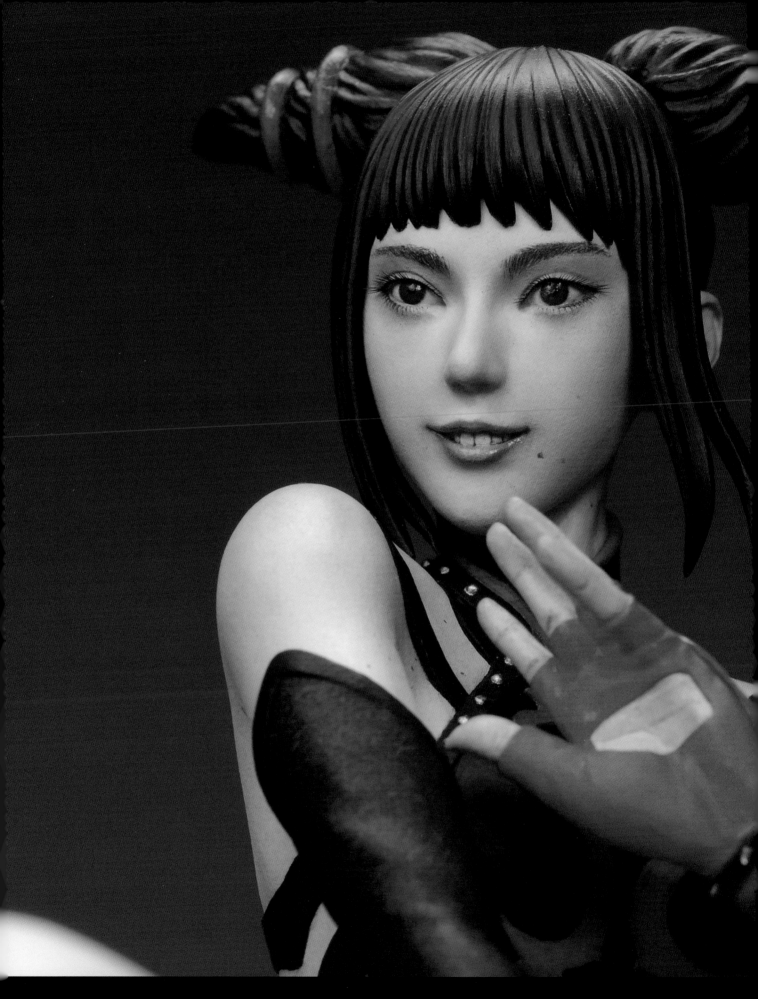

01

韓蛛俐 1 號機
Han Juri 1

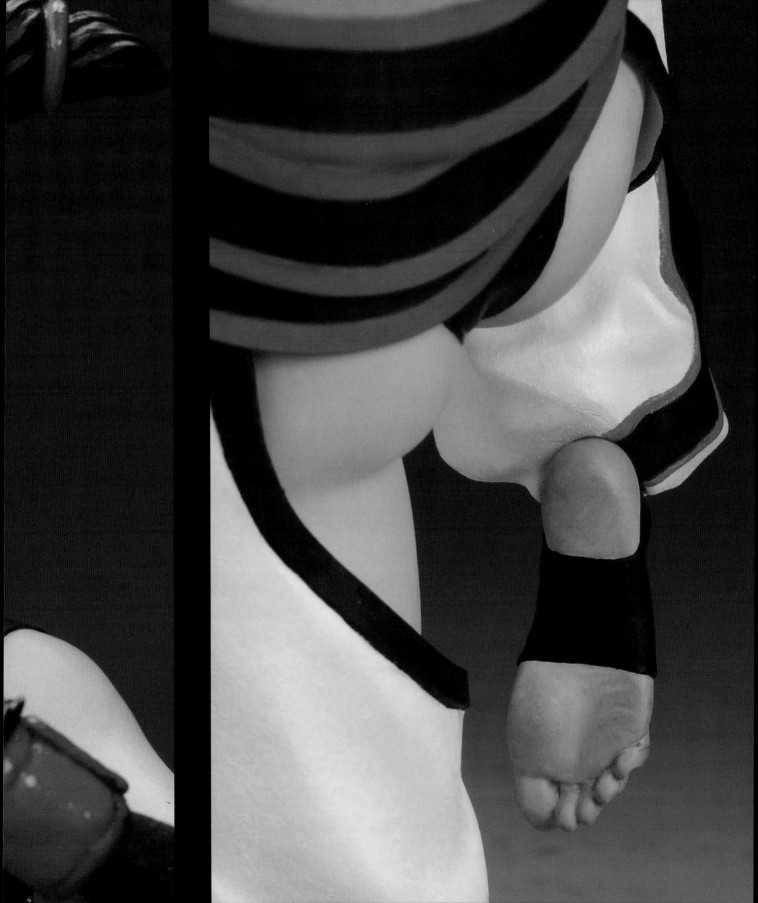

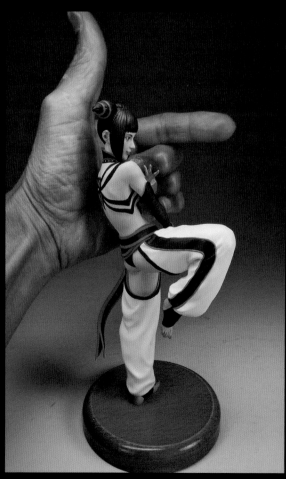

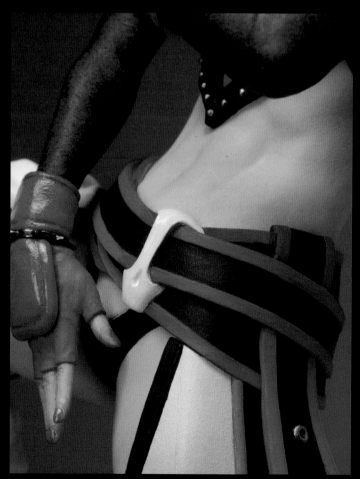

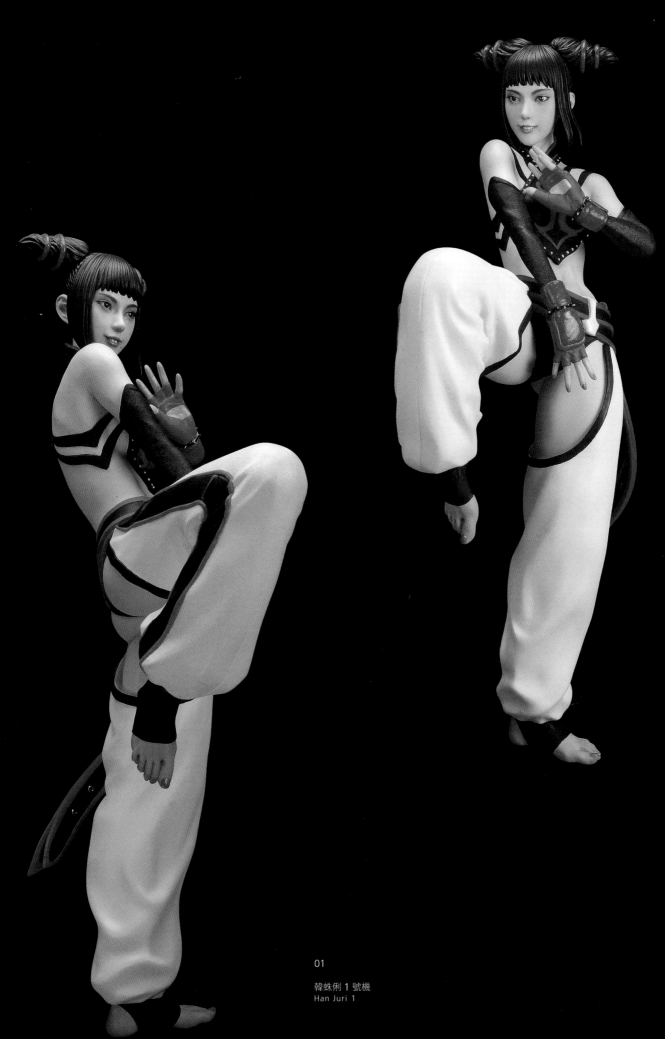

01

韓蛛俐 1 號機
Han Juri 1

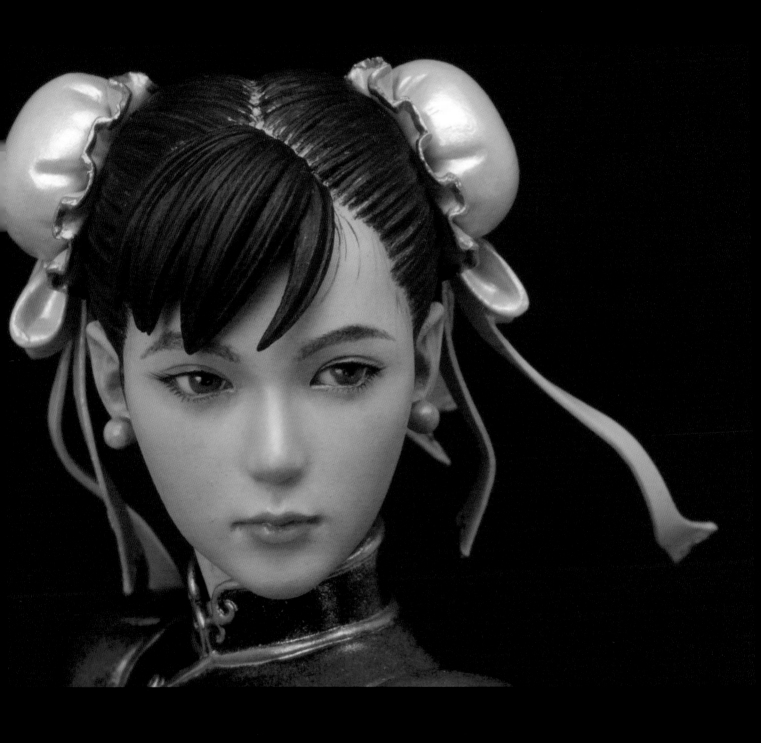

02

春麗1號機
Chun-Li 1

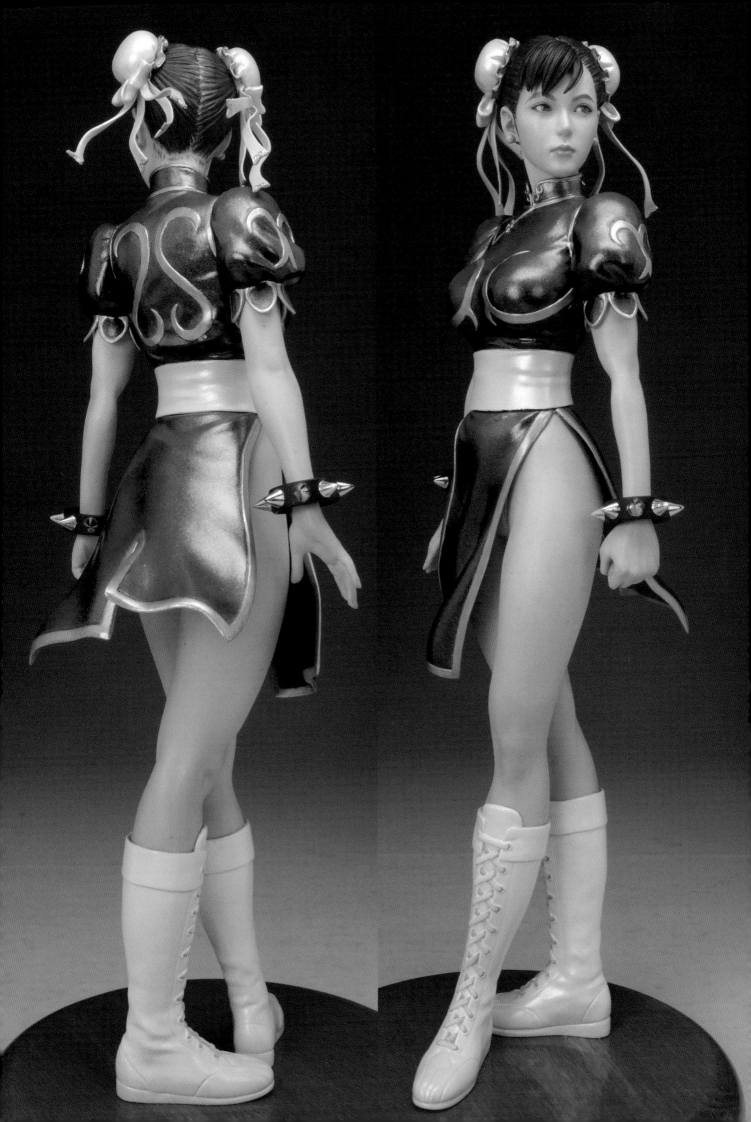

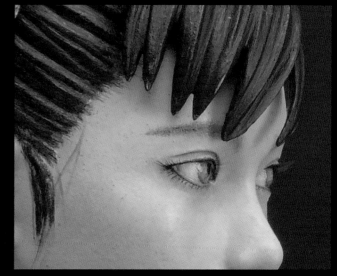

02

春麗1號機
Chun-Li 1

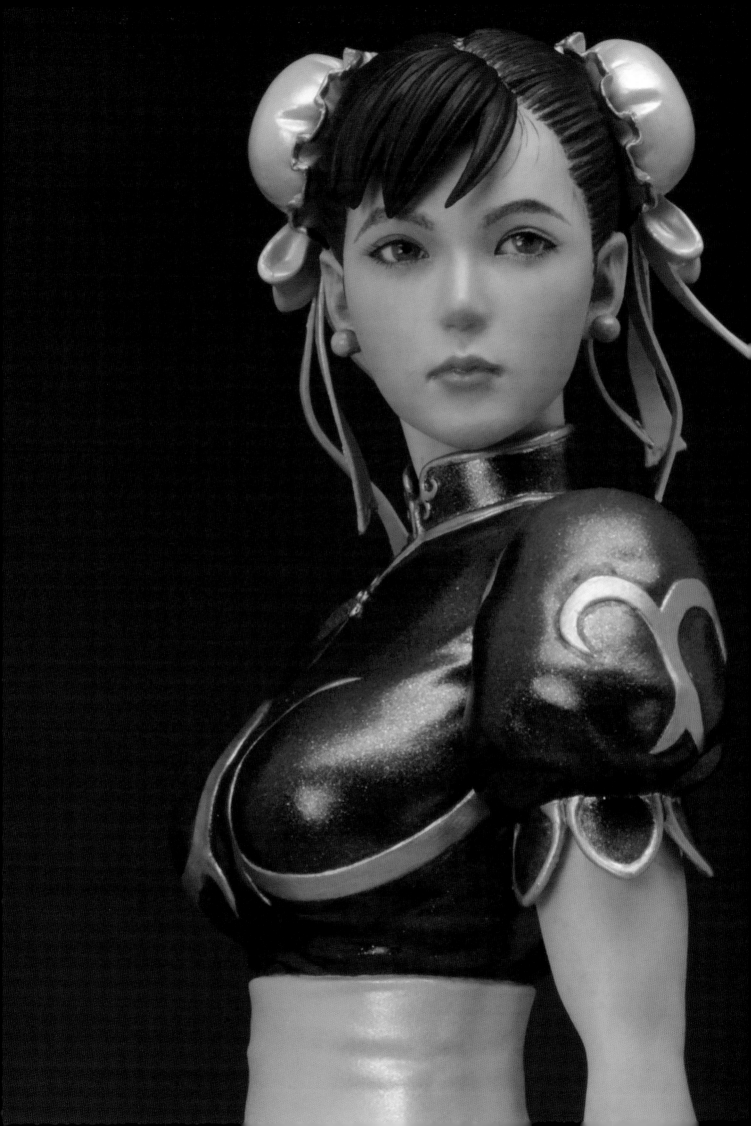

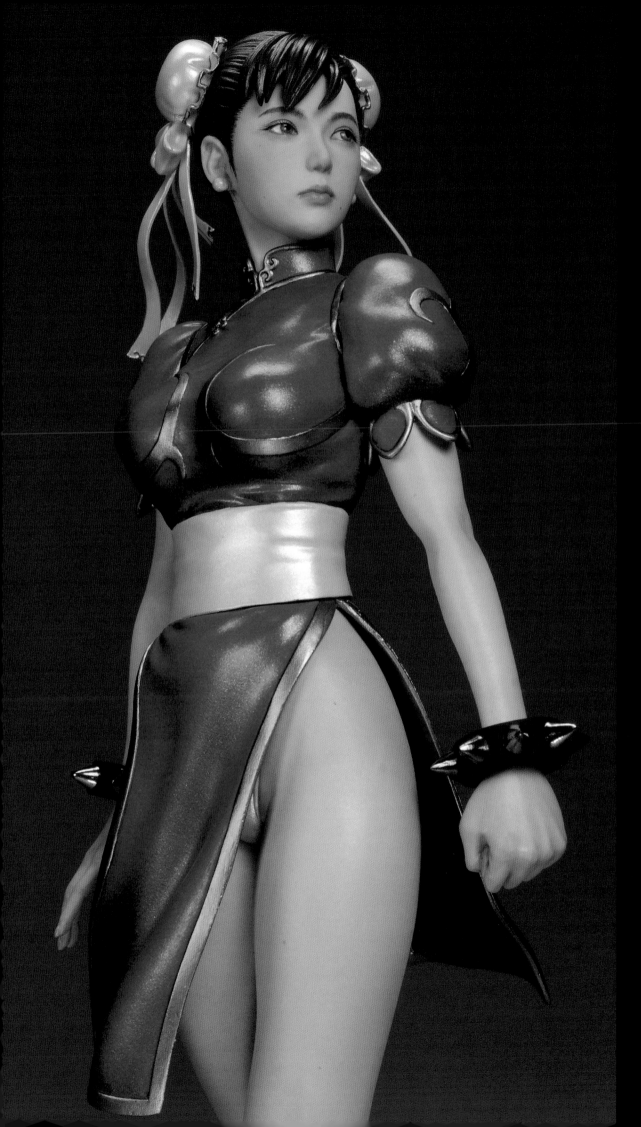

02

春麗1號機
Chun-Li 1

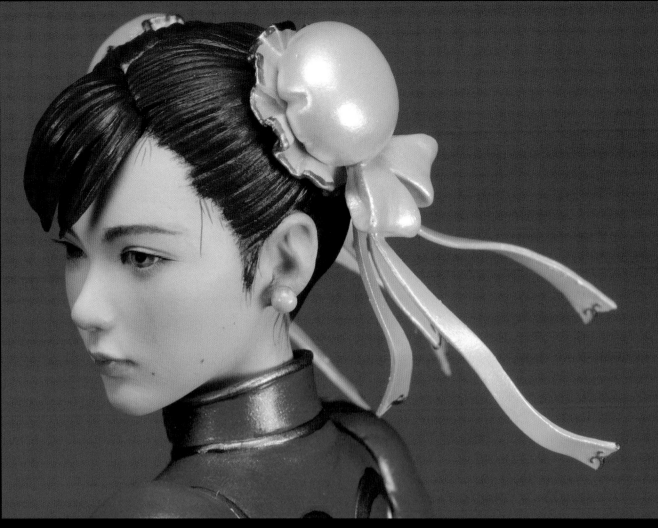

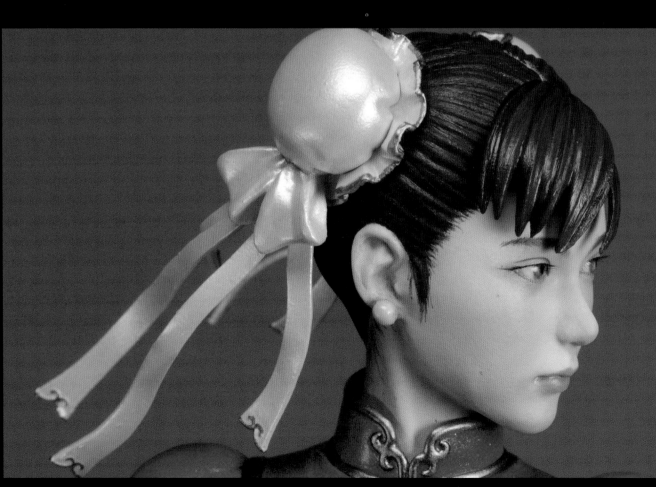

02

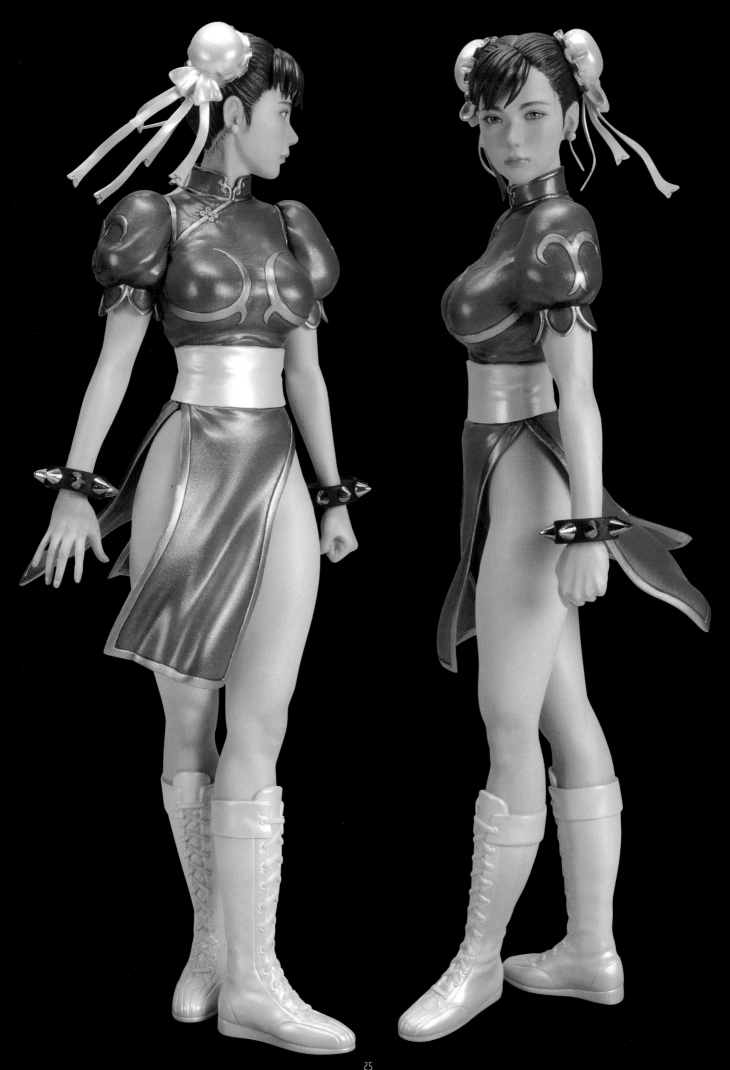

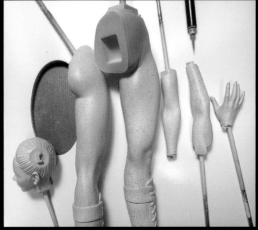
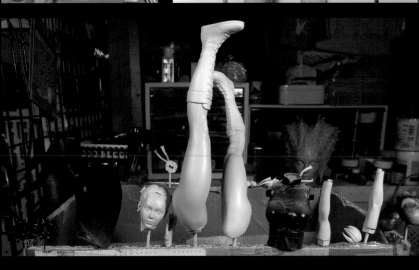
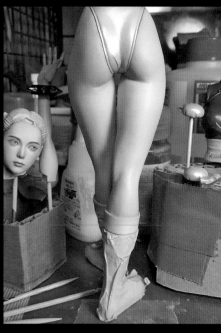
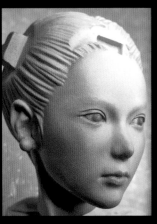
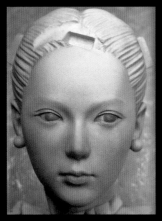
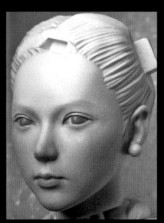
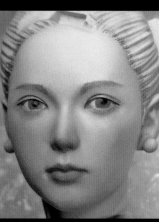
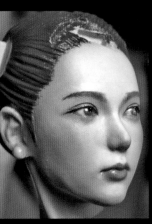
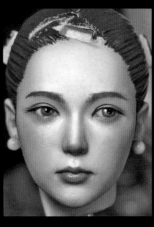
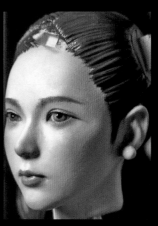
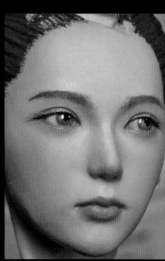

春麗 1 號機
Chun-Li 1

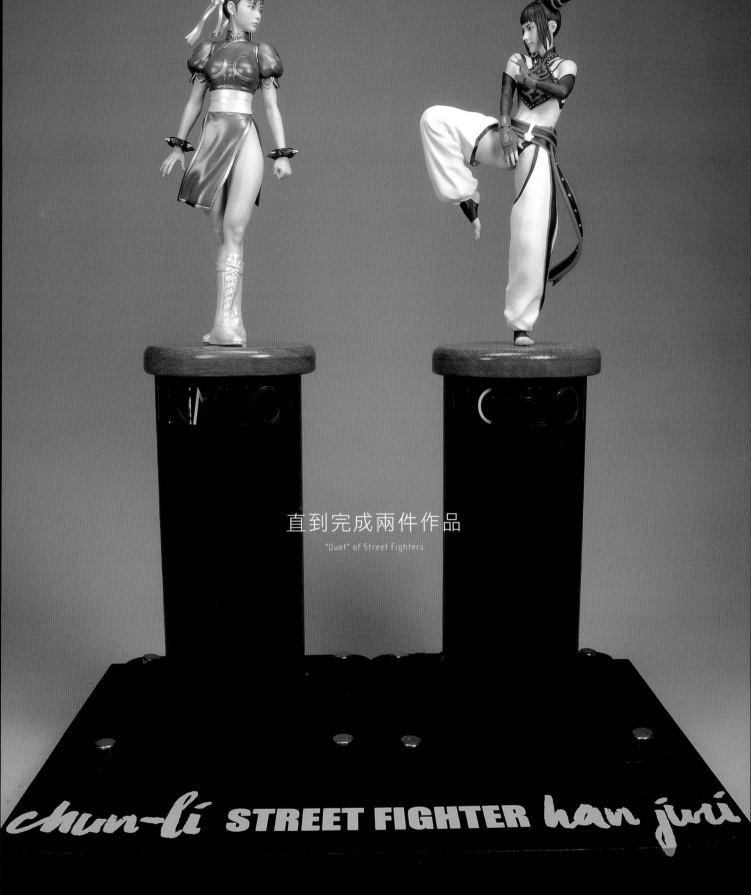

直到完成兩件作品
"Duet" of Street Fighters

chun-li STREET FIGHTER han juri

若角色已經有完整的設定和個性描述，田川弘不會帶
入過多的個人情感，而是以角色形象為基礎，專注在
如何展現出立體作品的魅力。

When painting popular characters with a well-defined setting and
backstory, Tagawa does his best not to break the image of the
original subject. He will concentrate on expressing the character
attractively as a three-dimensional figure by cohabiting its backstory
and the beauty as a figure.

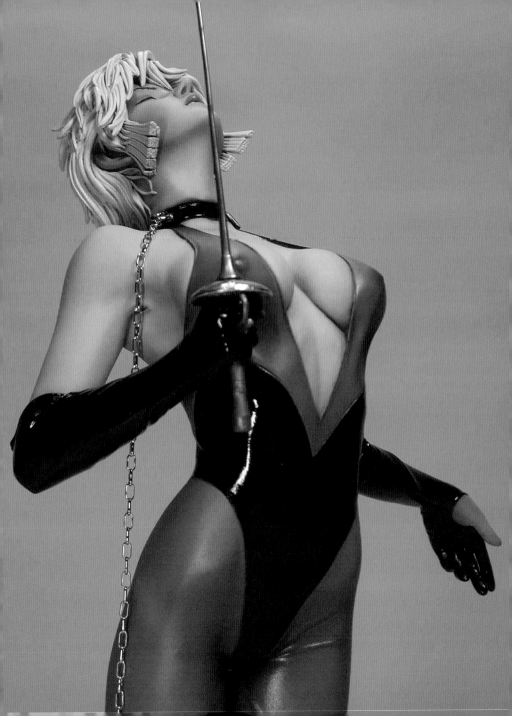

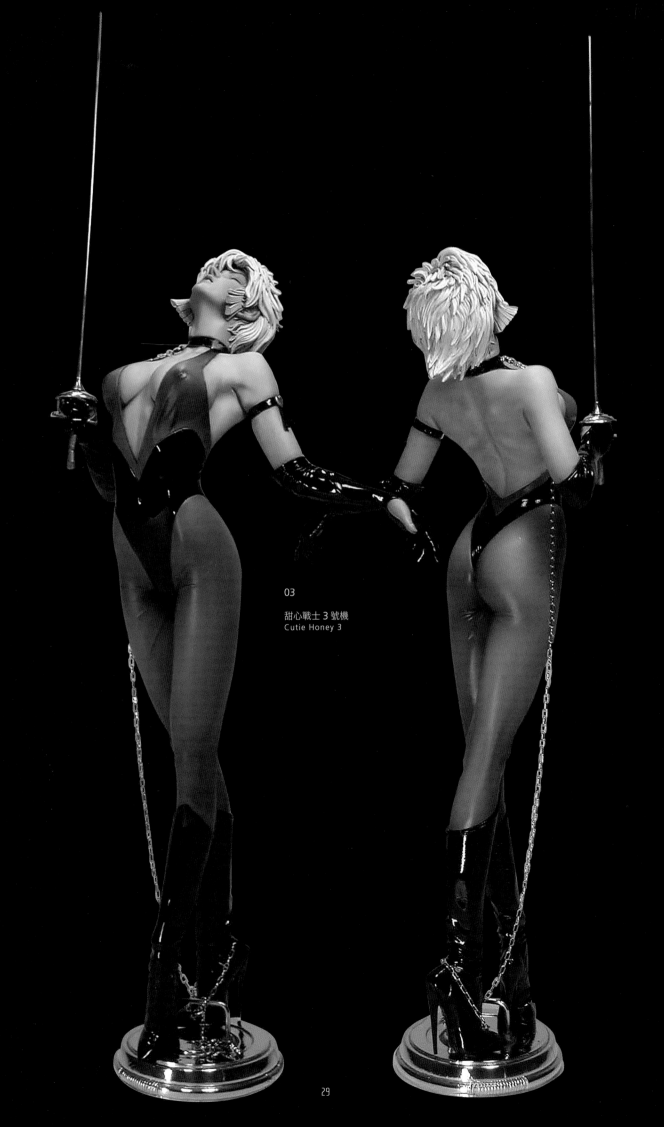

03

甜心戰士 3 號機
Cutie Honey 3

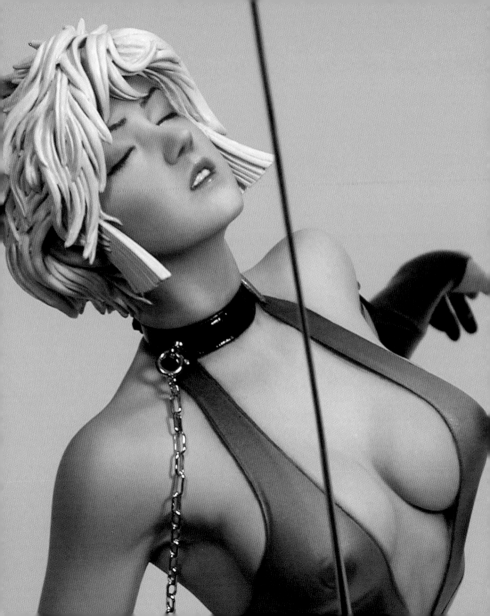

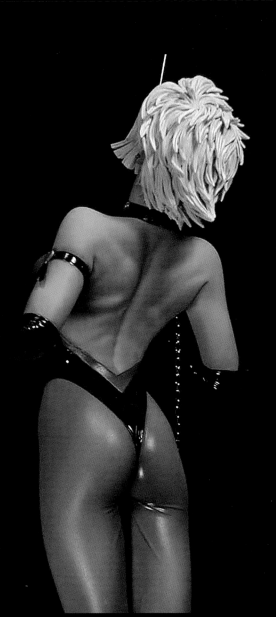

03

甜心戰士 3 號機
Cutie Honey 3

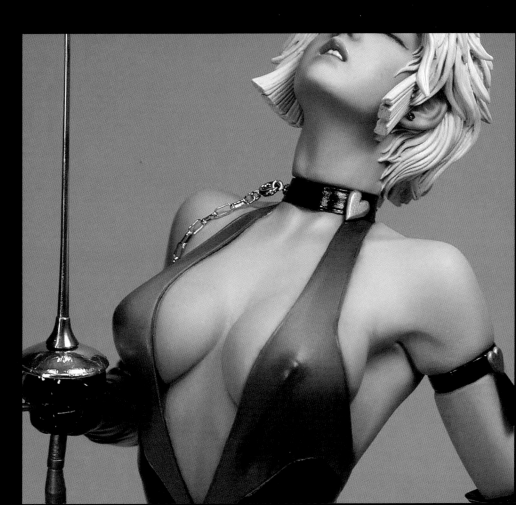

惡魔娘篠崎 2 號機
Shinozaki-san 02

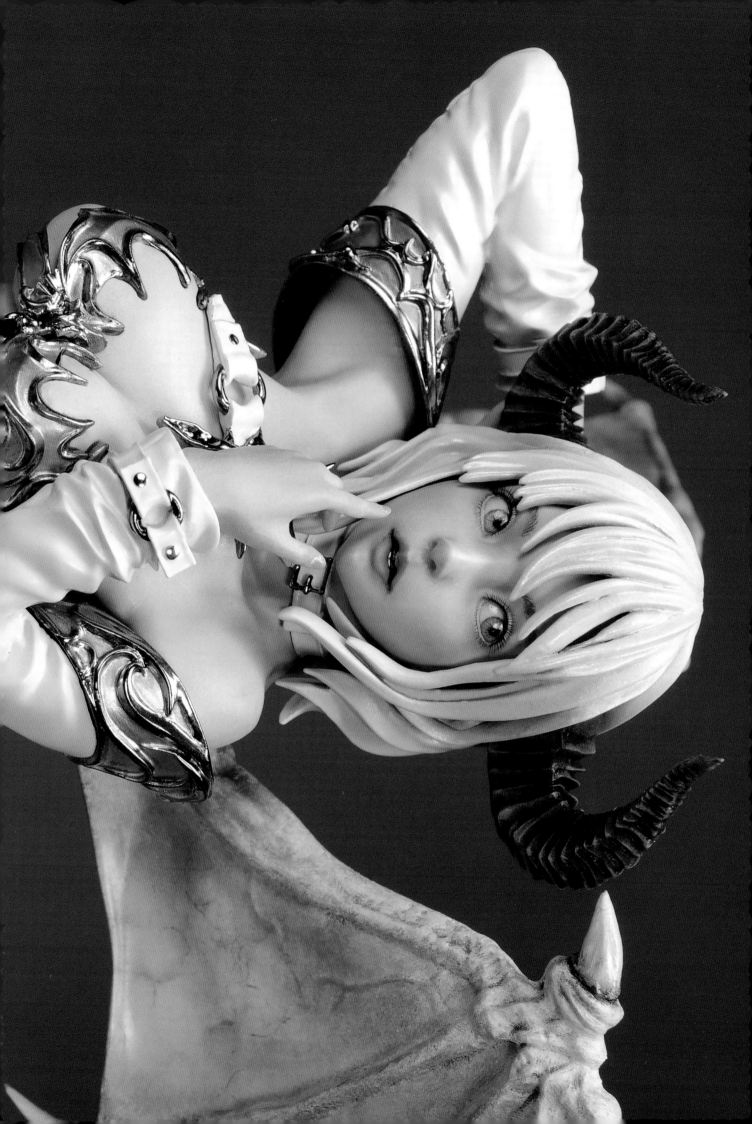

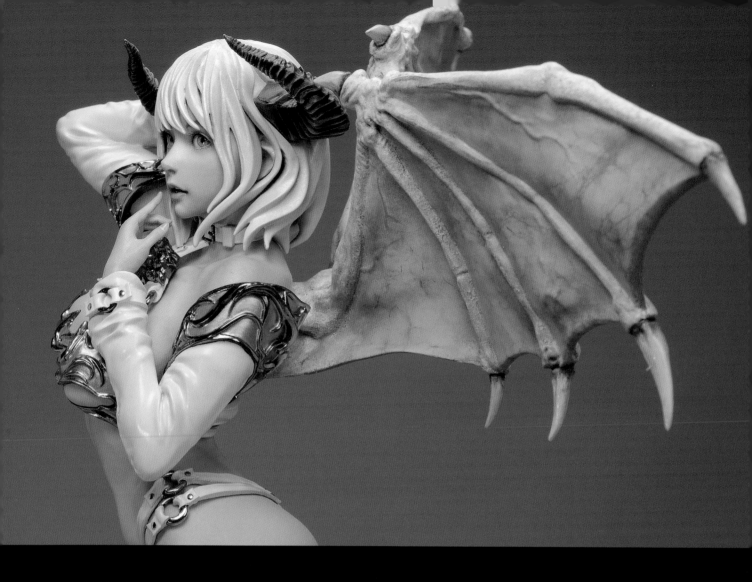

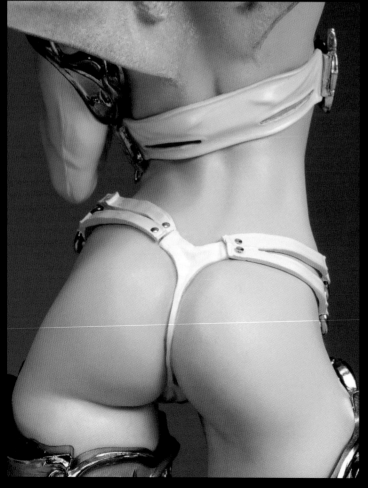

04

惡魔娘篠崎 2 號機
Shinozaki-san 02

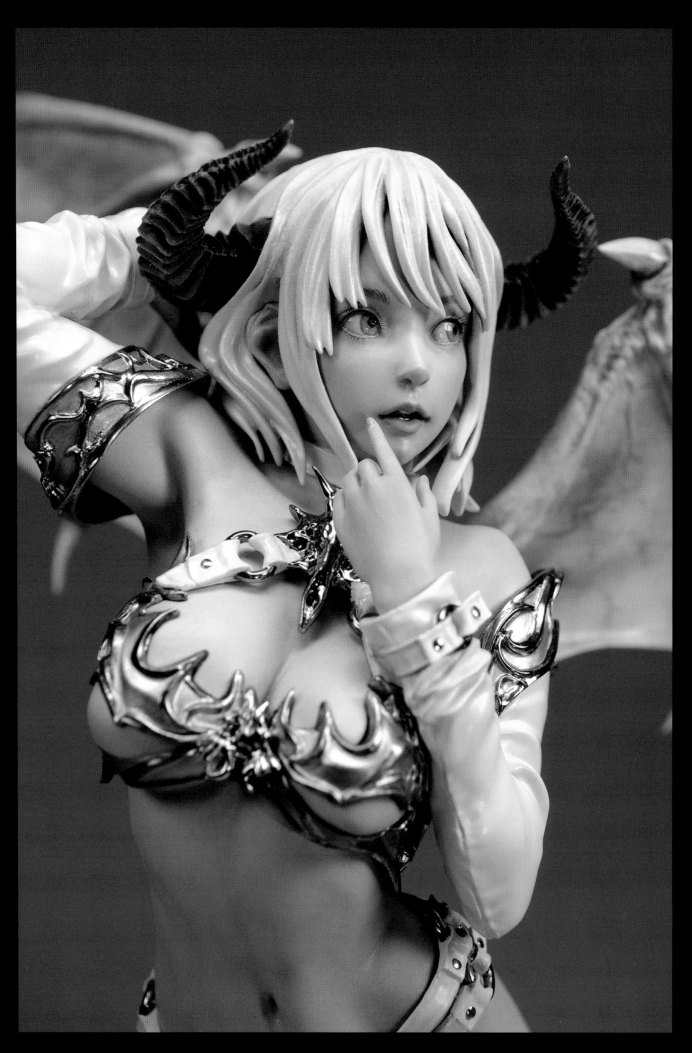

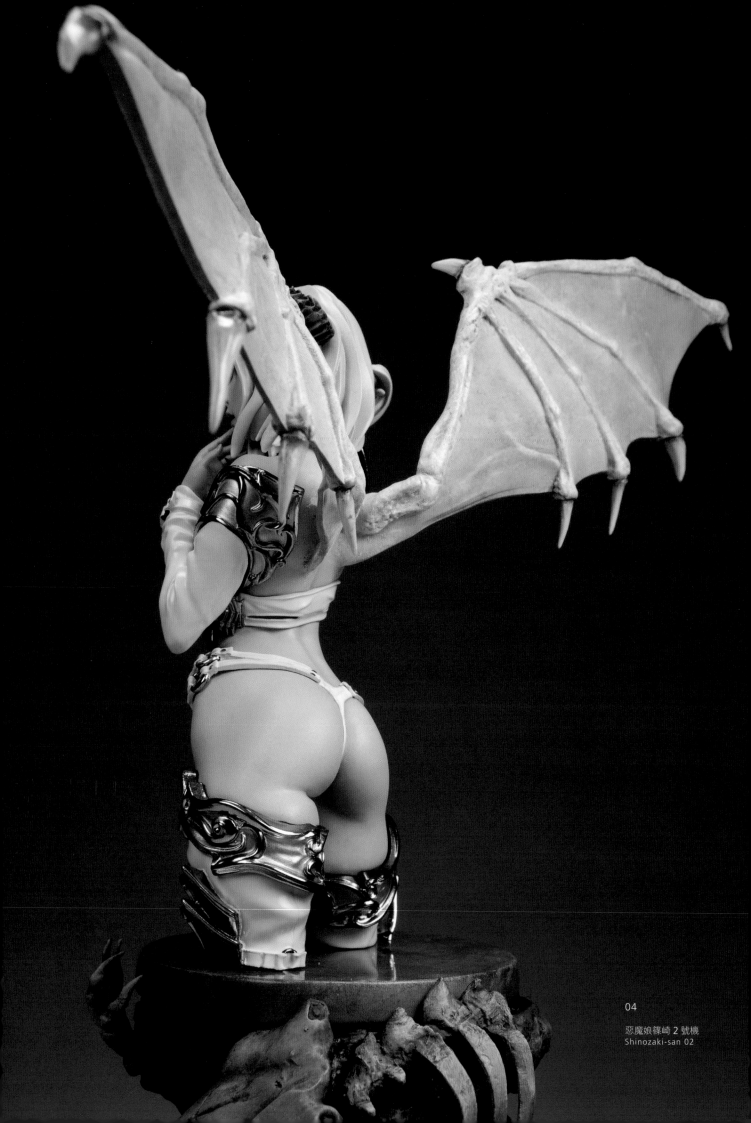

04

惡魔娘篠崎 2 號機
Shinozaki-san 02

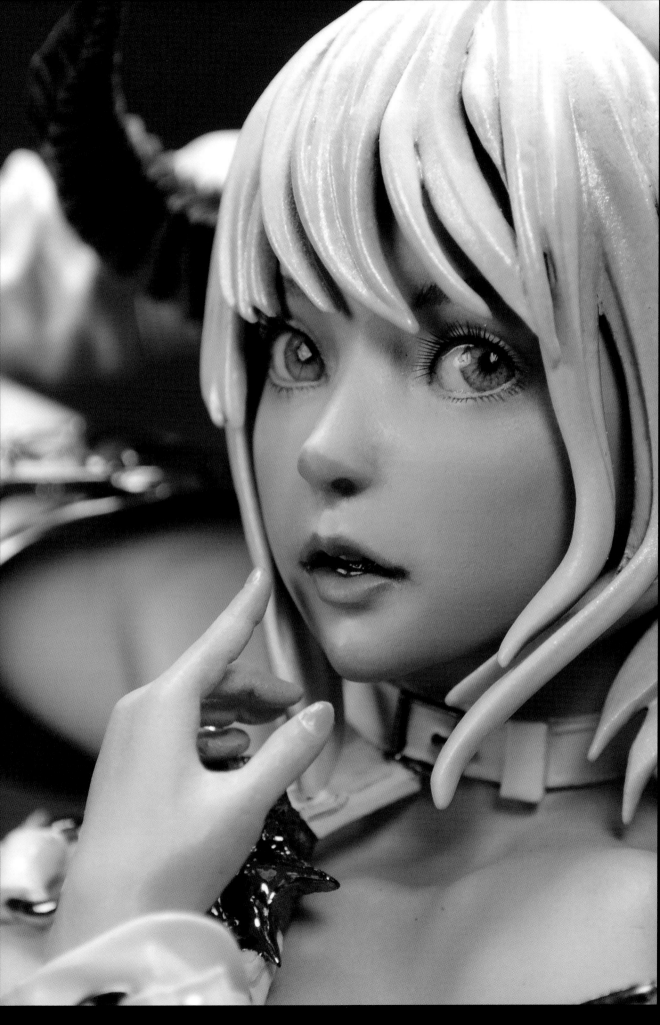

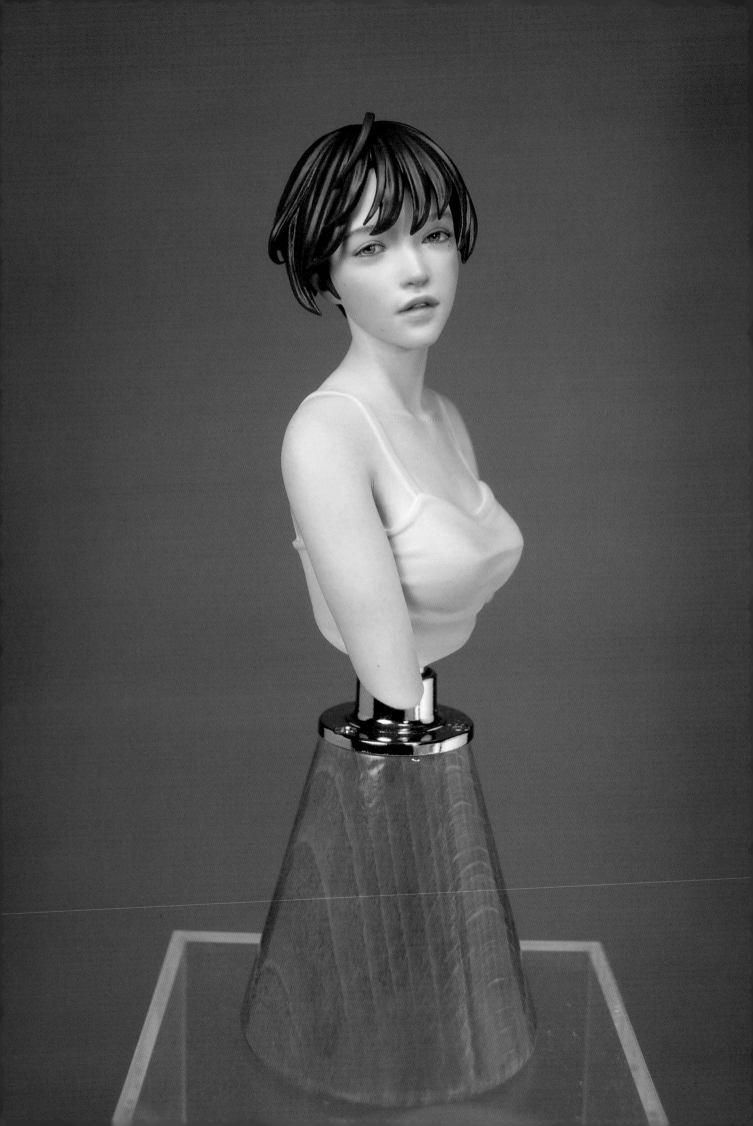

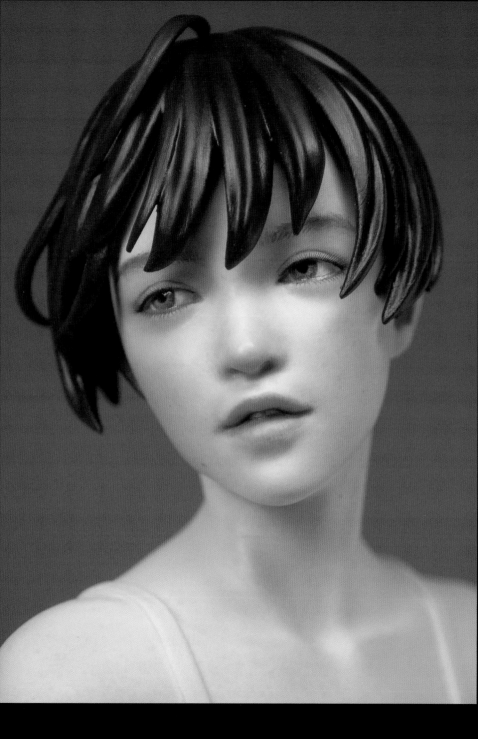

PB-01　1號機
PB-01 01

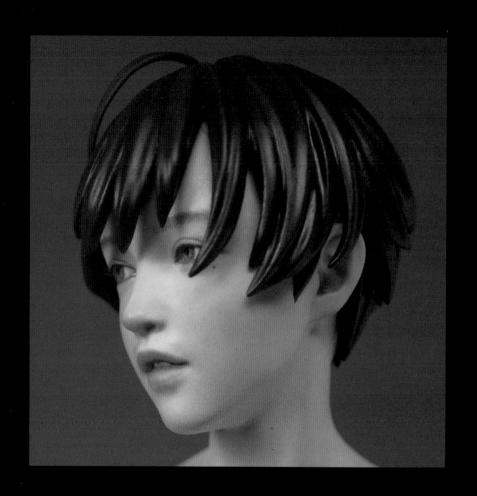

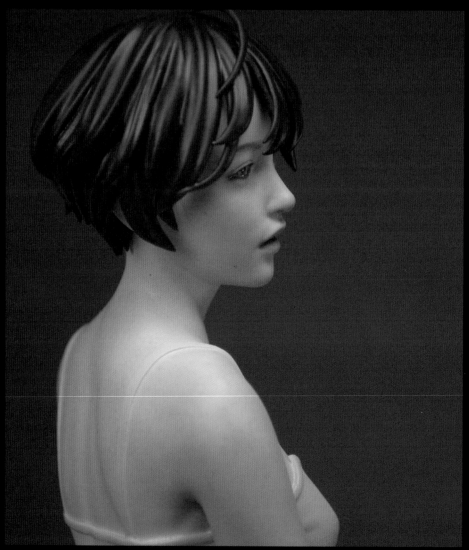

05

PB-01　1號機
PB-01 01

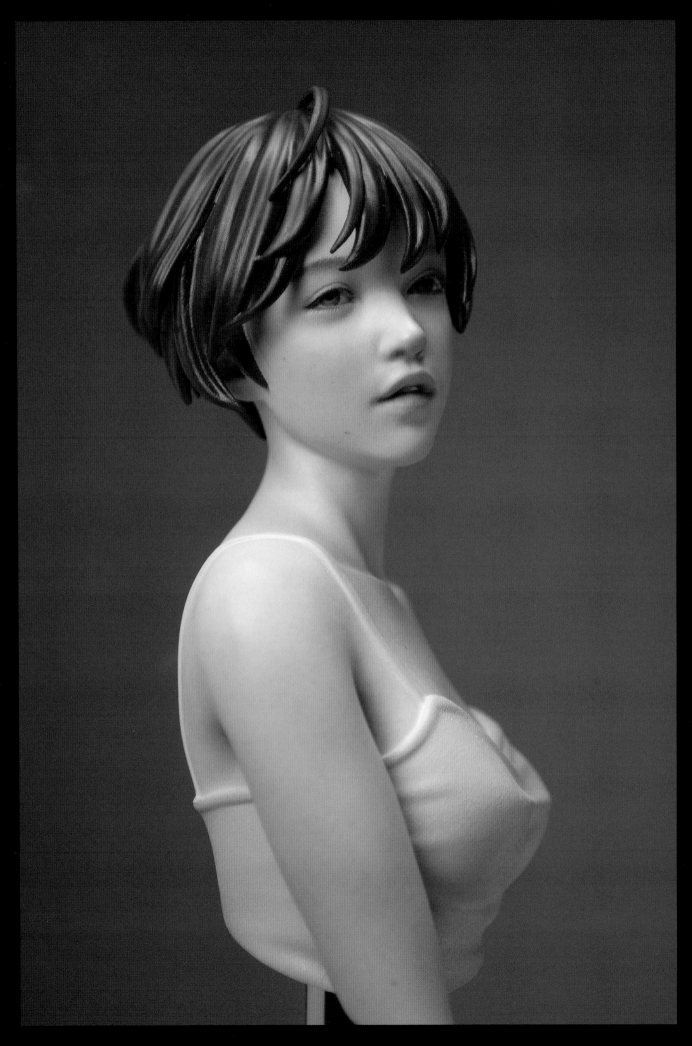

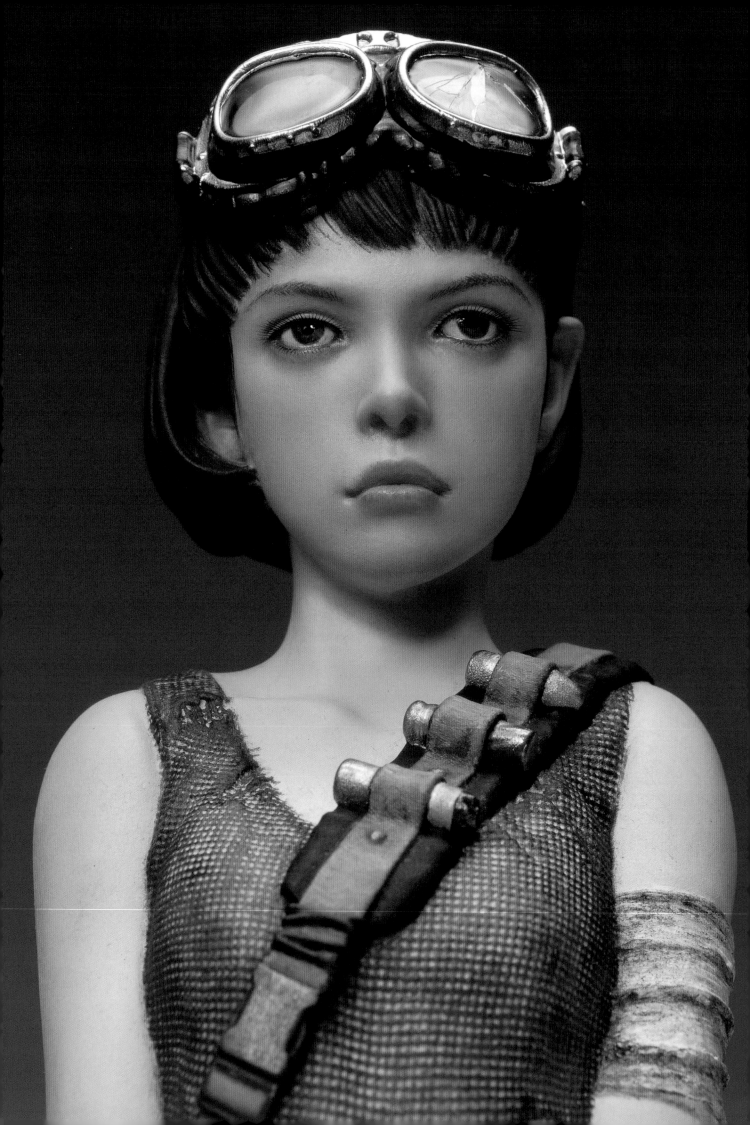

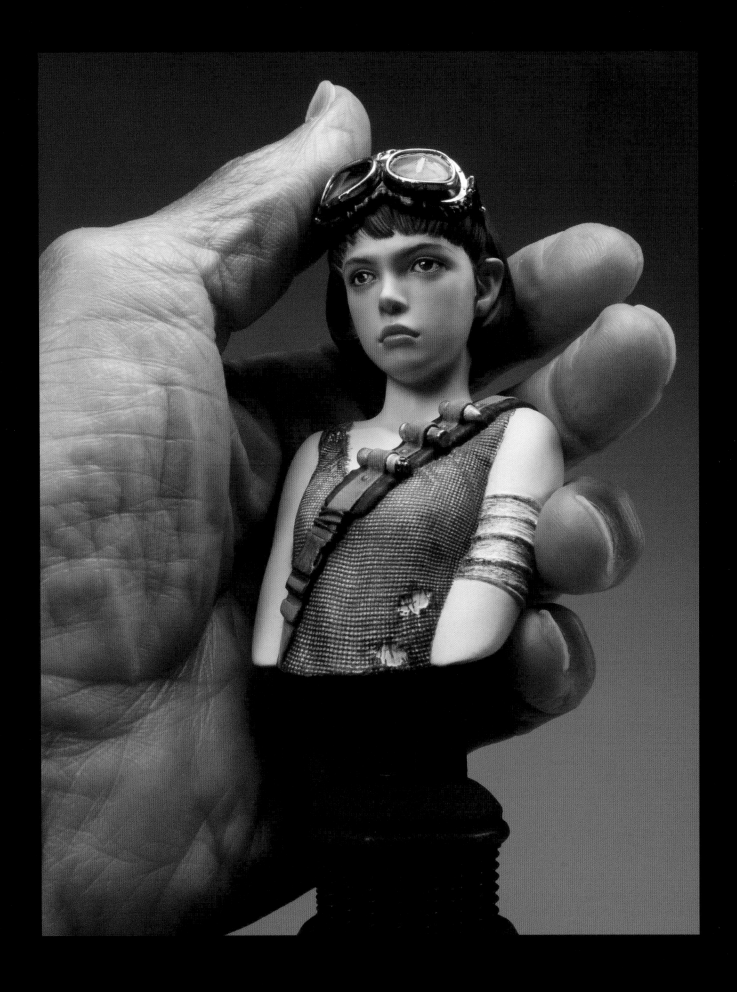

06

Black Rock City　2號機
Black Rock City 02

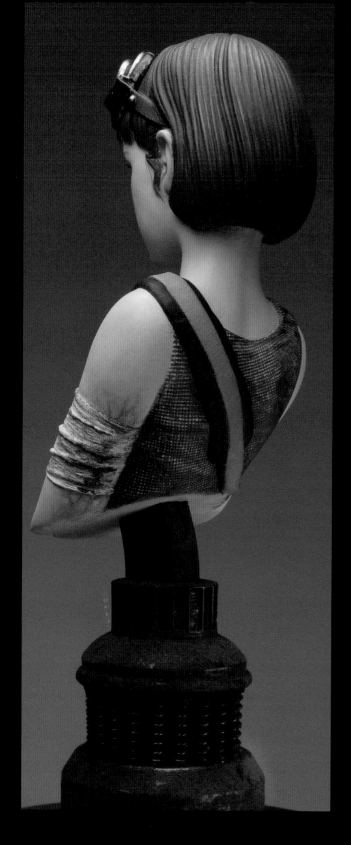

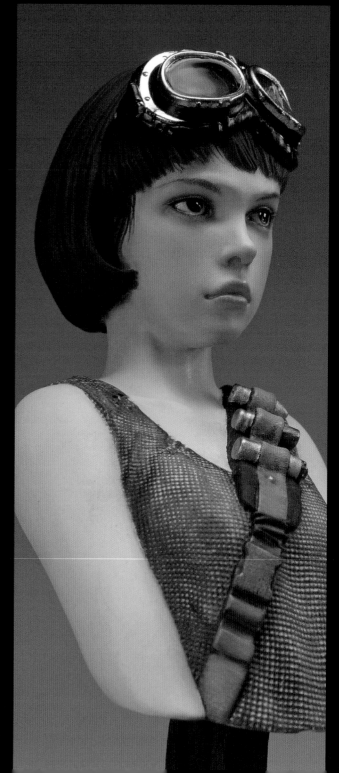

06

Black Rock City　2號機
Black Rock City 02

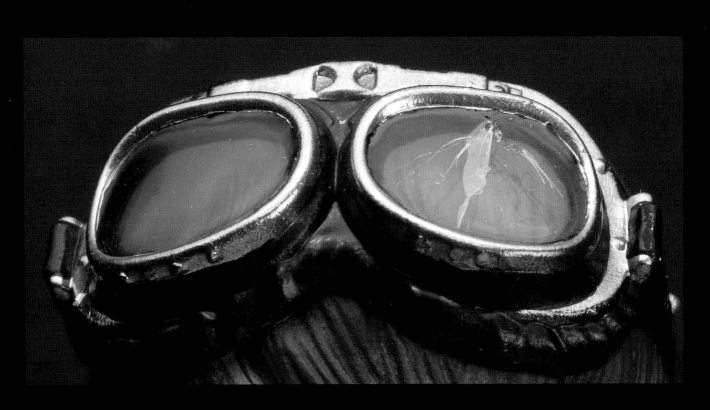

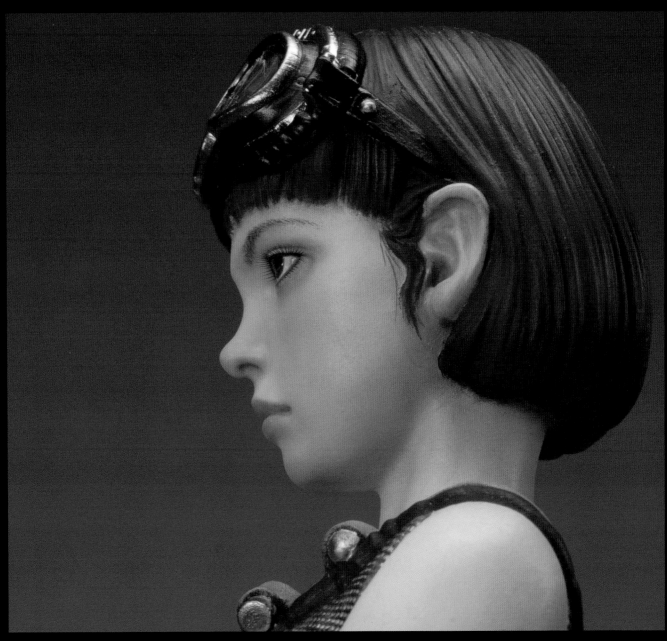

'Bye Bye Baby
'Bye Bye Baby

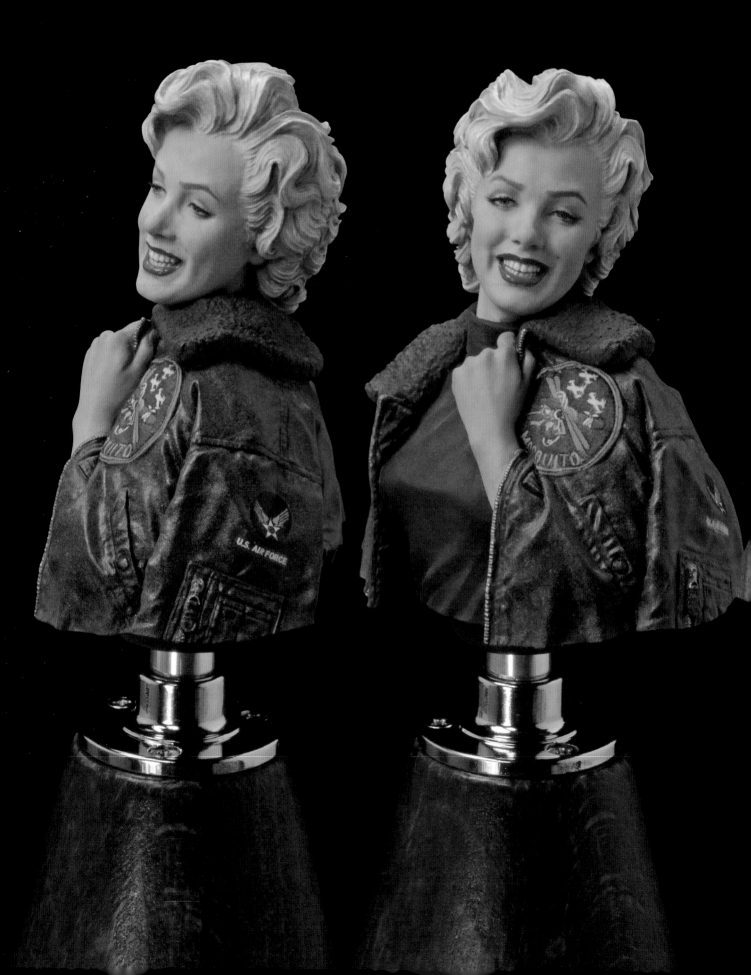

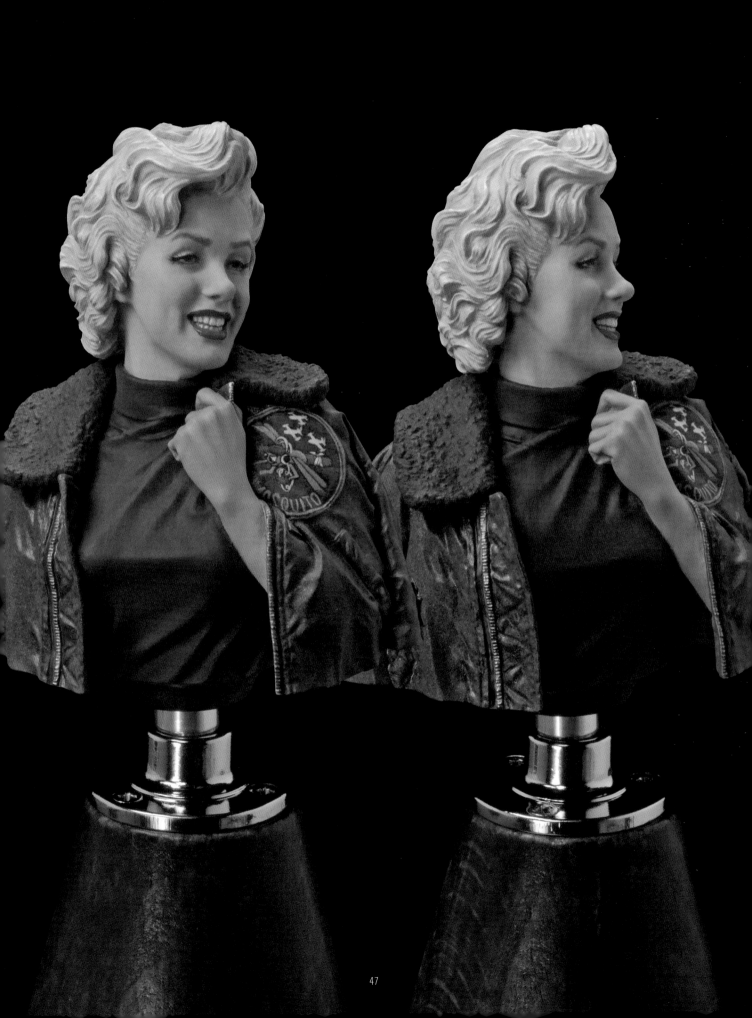

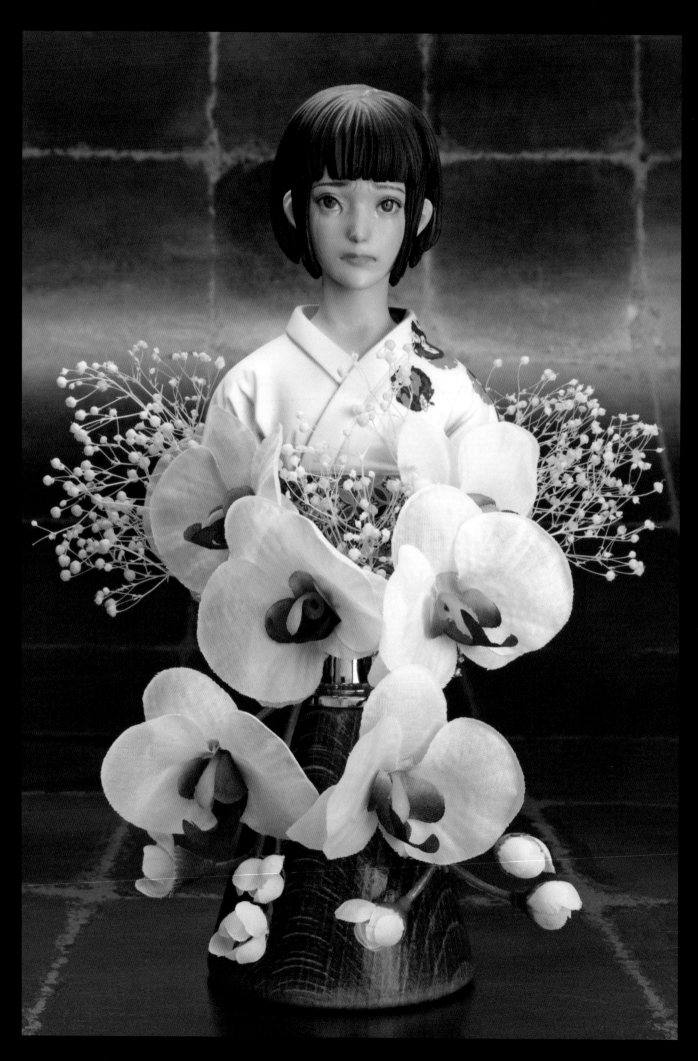

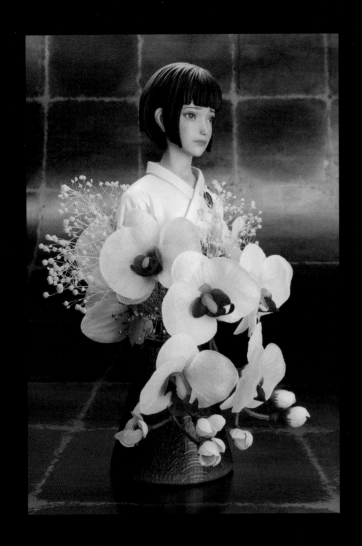
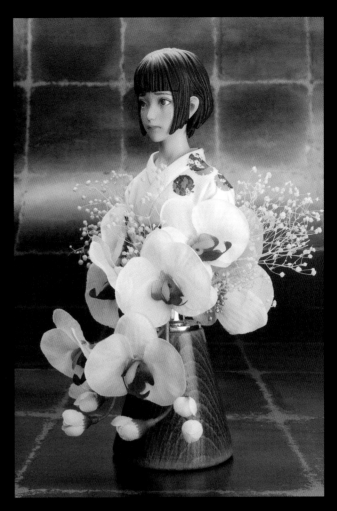
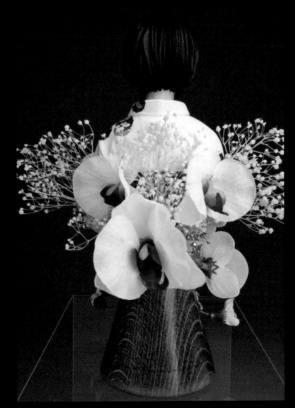

08

eri artwork 『紙飛機的去向』
eri artwork 『whereabouts of paper plane』

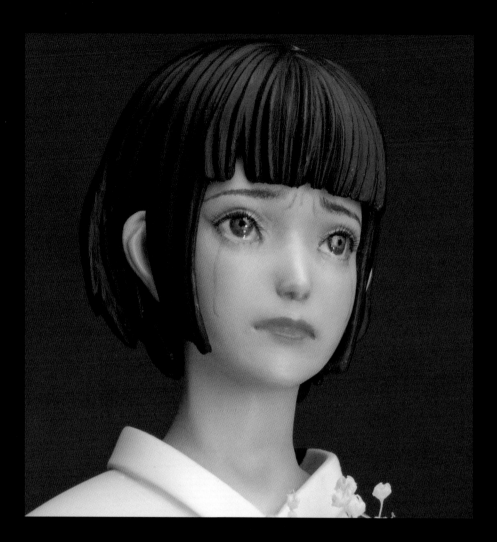

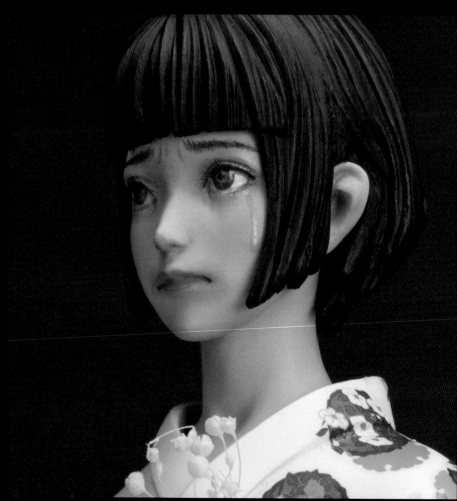

eri artwork 『紙飛機的去向』
eri artwork 『whereabouts of paper plane』

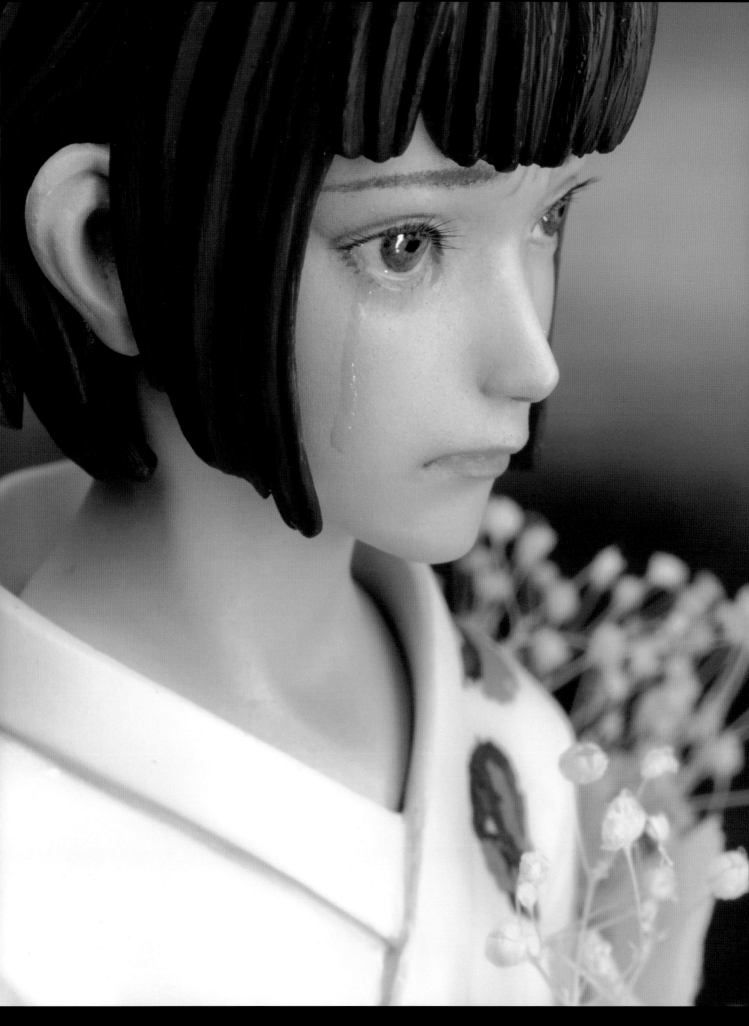

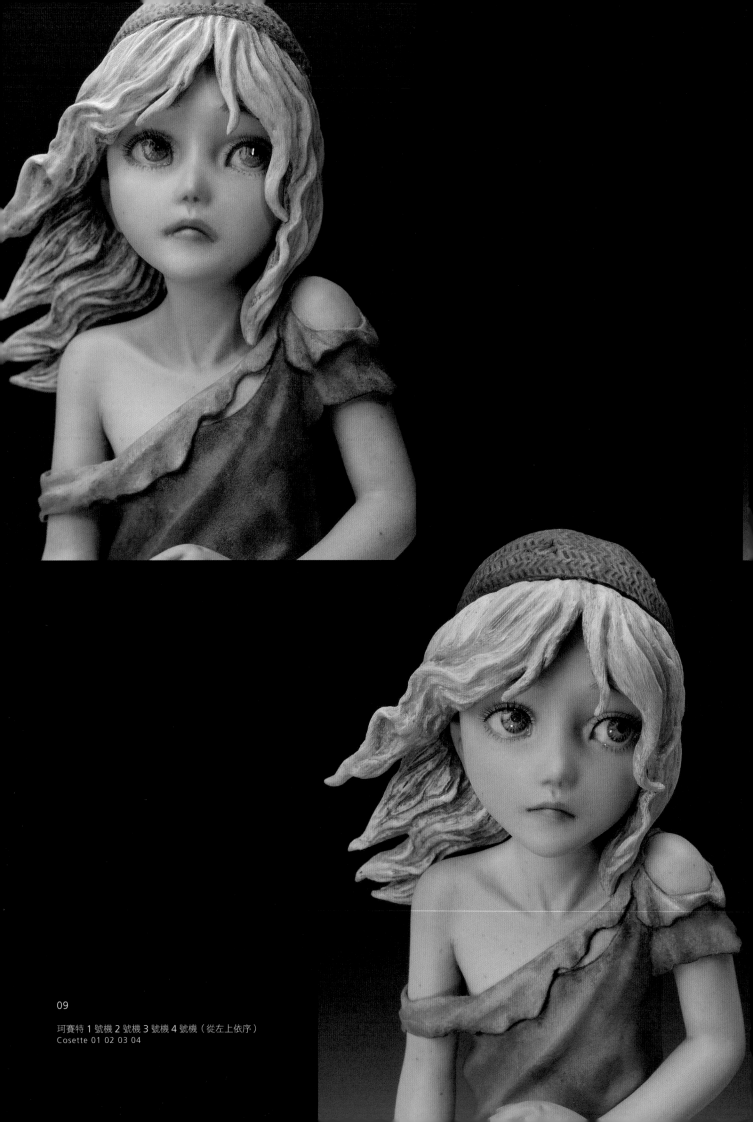

珂賽特 1 號機 2 號機 3 號機 4 號機（從左上依序）
Cosette 01 02 03 04

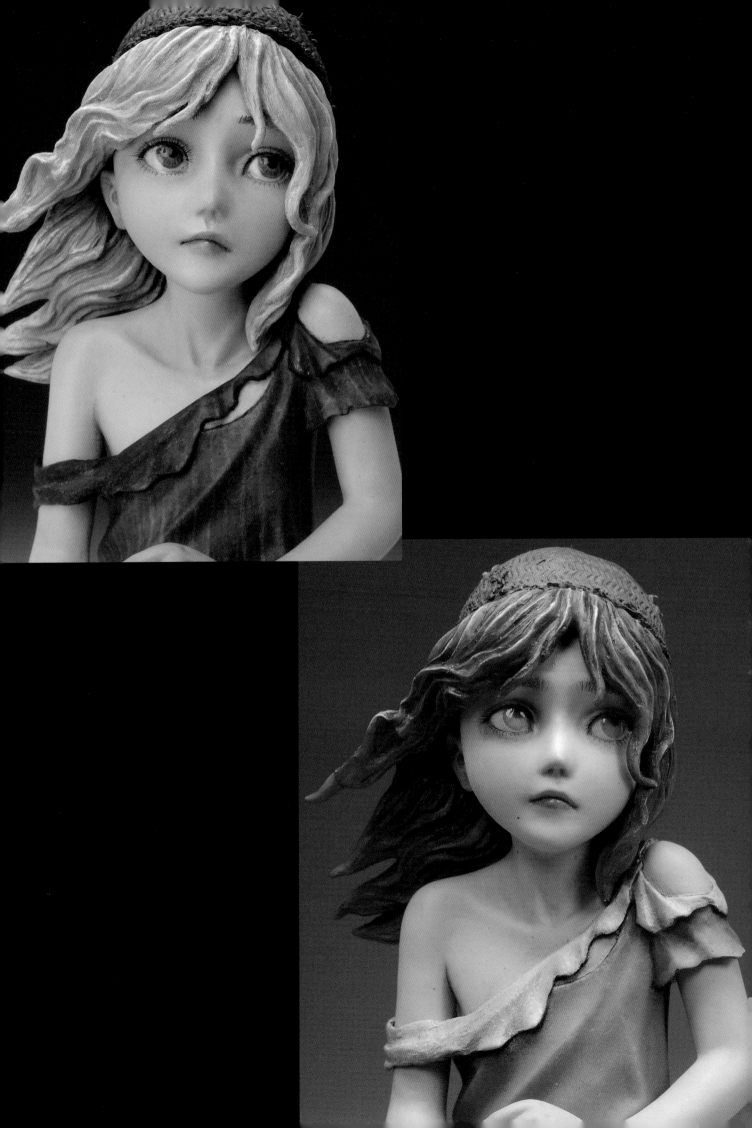

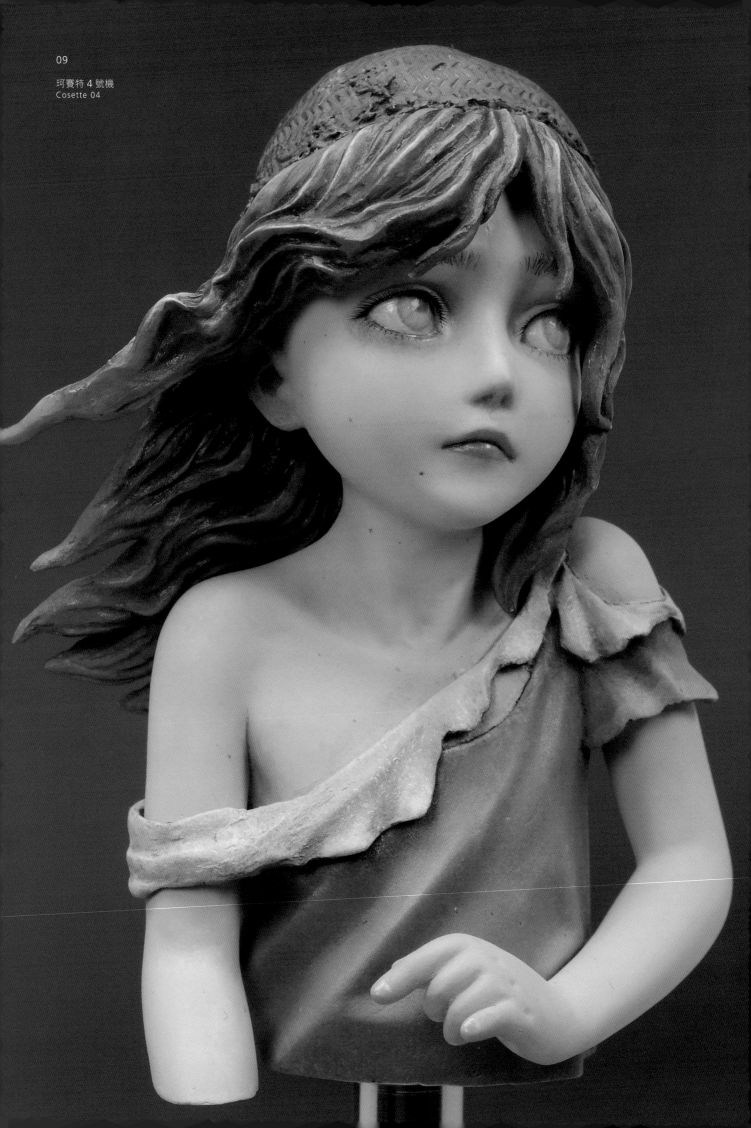

珂賽特 4 號機
Cosette 04

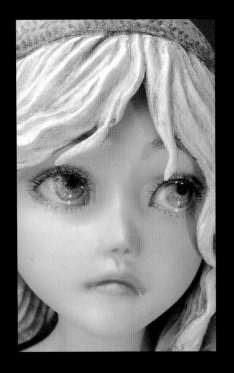
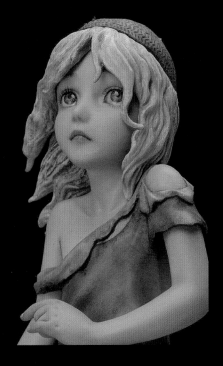
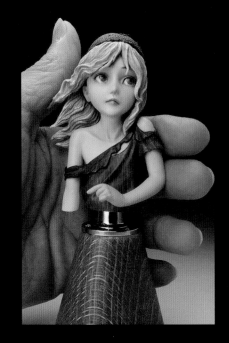
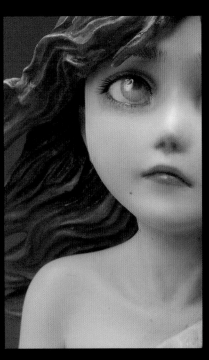

關於半身像的構思
Thoughts on the bust

半身像比全身像主題的塗裝面積小、零件數量也較少，實際打底時也只需花費一半的時間。由於實際作業的步驟相對較少，當田川弘塗裝全身像感到疲累時，通常會轉為塗裝半身像稍作歇息。另一方面，半身像塗裝會透露出原型師的品味，而這點是無法從全身像看出，例如：要擷取人物的哪一個部分？要如何修飾剖面？這些處理「半身像特有外觀」時才可改造的設計，也是半身像塗裝的魅力之一。

Compared to full-length figures, bust figures typically requires a smaller painting area. They are composed of fewer parts and take about half the time to prepare before painting. Having to do fewer steps directly contributes to less workload. This is why Tagawa prefers to work on bust figures when he wants some break. However, there is a unique challenge to bust figures. Tagawa must be extra precise when determining where to cut the figure and treat the cross-section with extra care. Such aspects are perfect for showing off one's talent and taste, which is one of the prime reasons why Tagawa enjoys working on a bust figure.

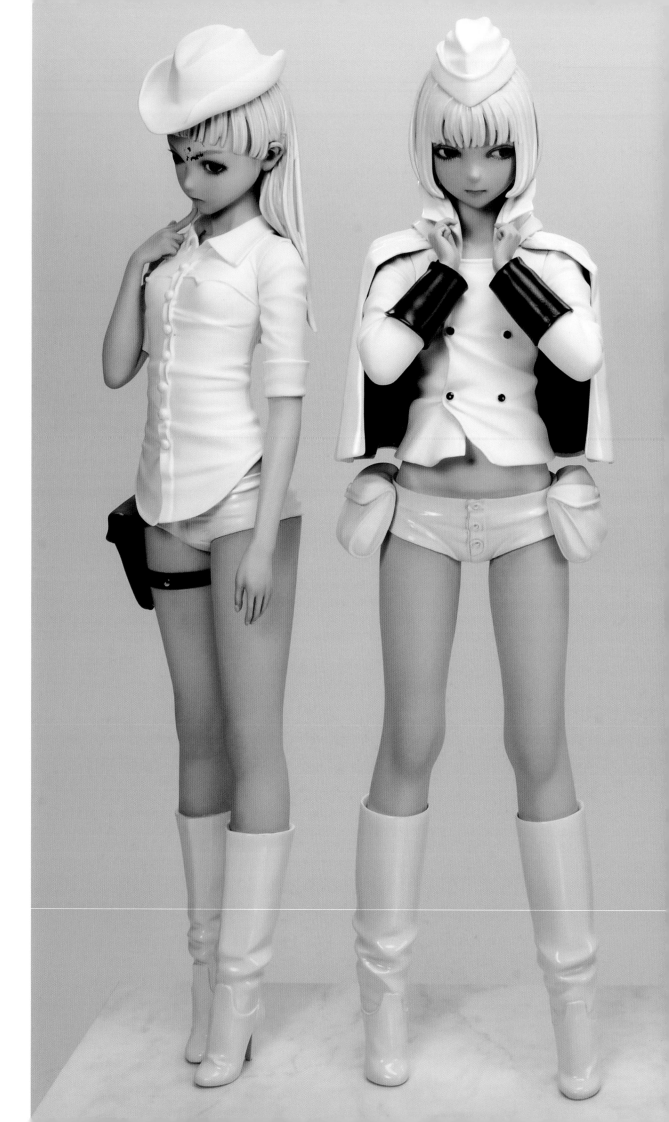

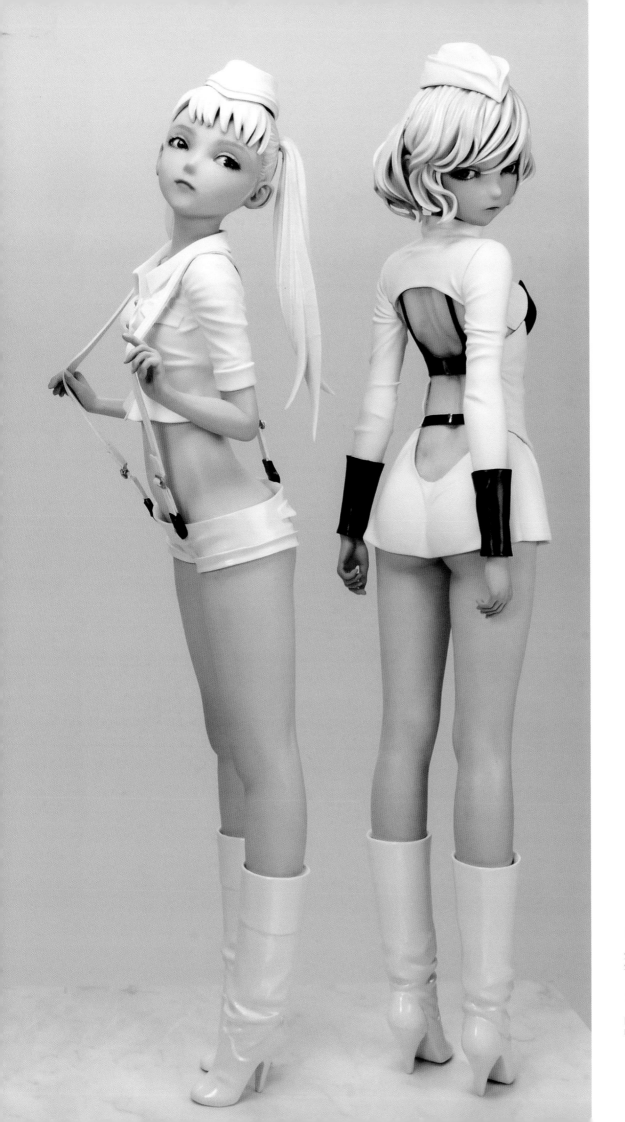

12
Soil
Soil

13
Luce
Luce

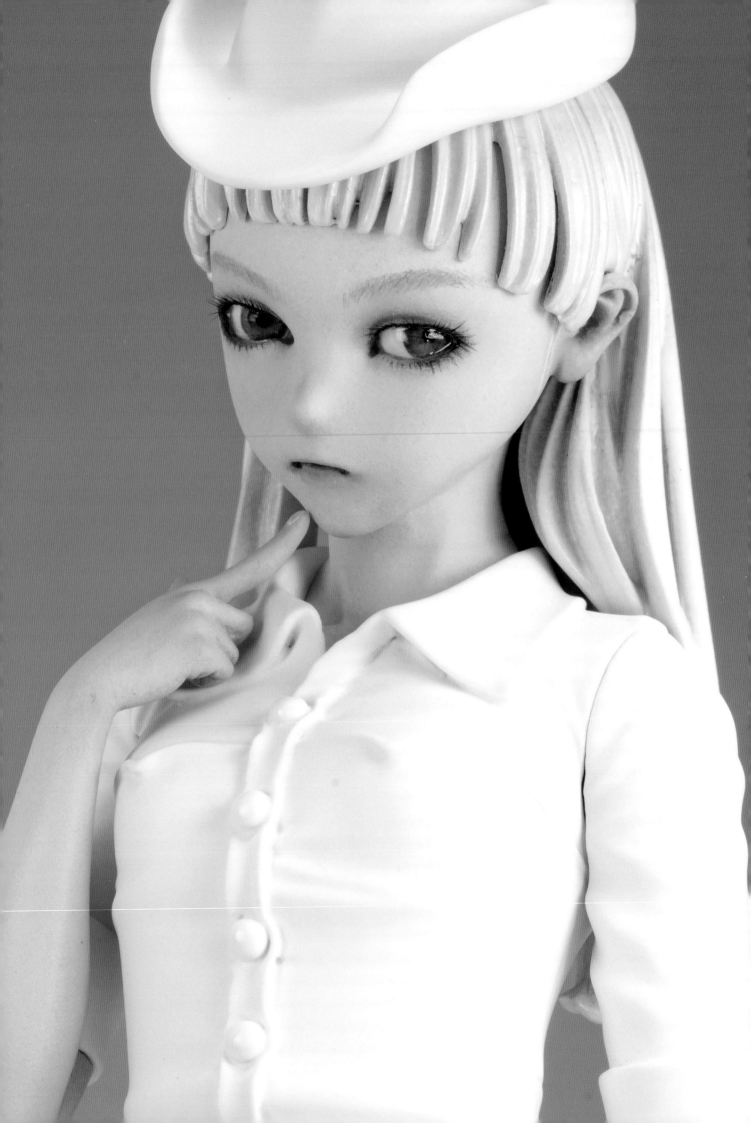

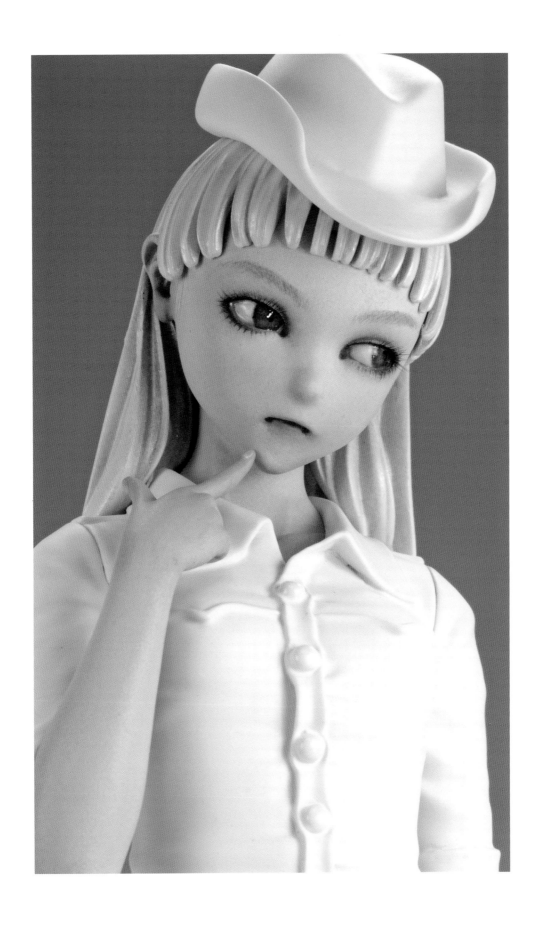

10

Konny
Konny

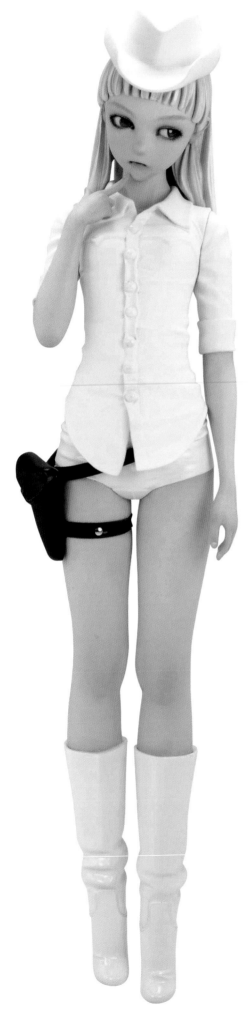
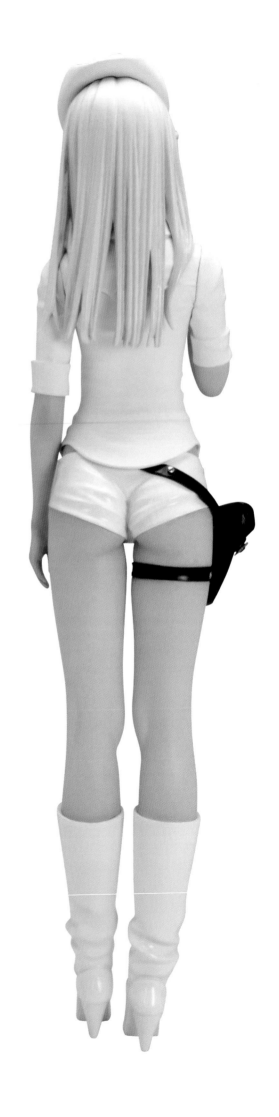

10

Konny
Konny

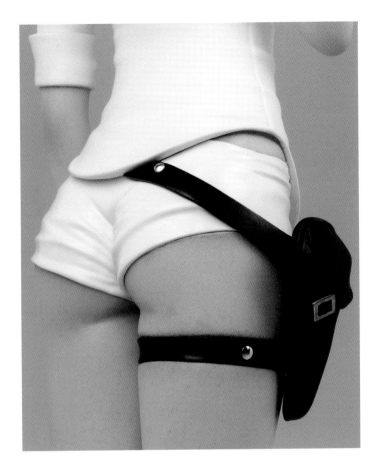
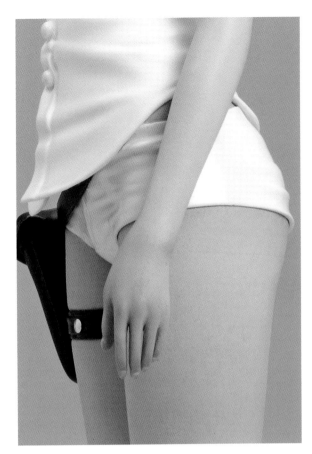
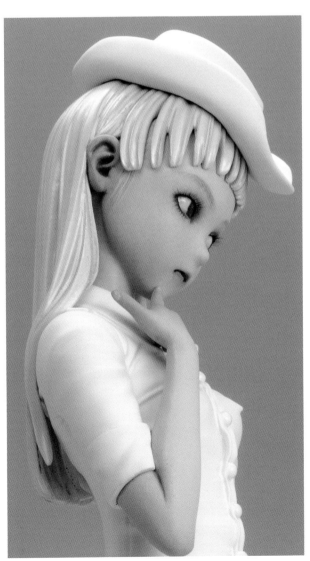
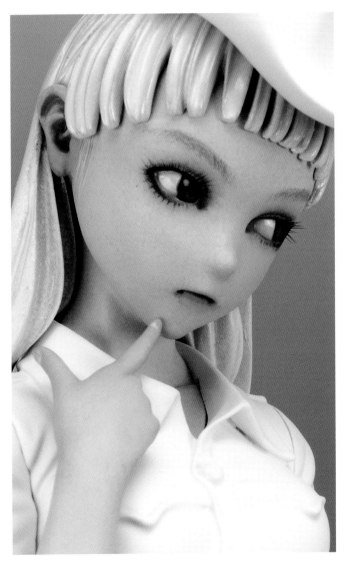

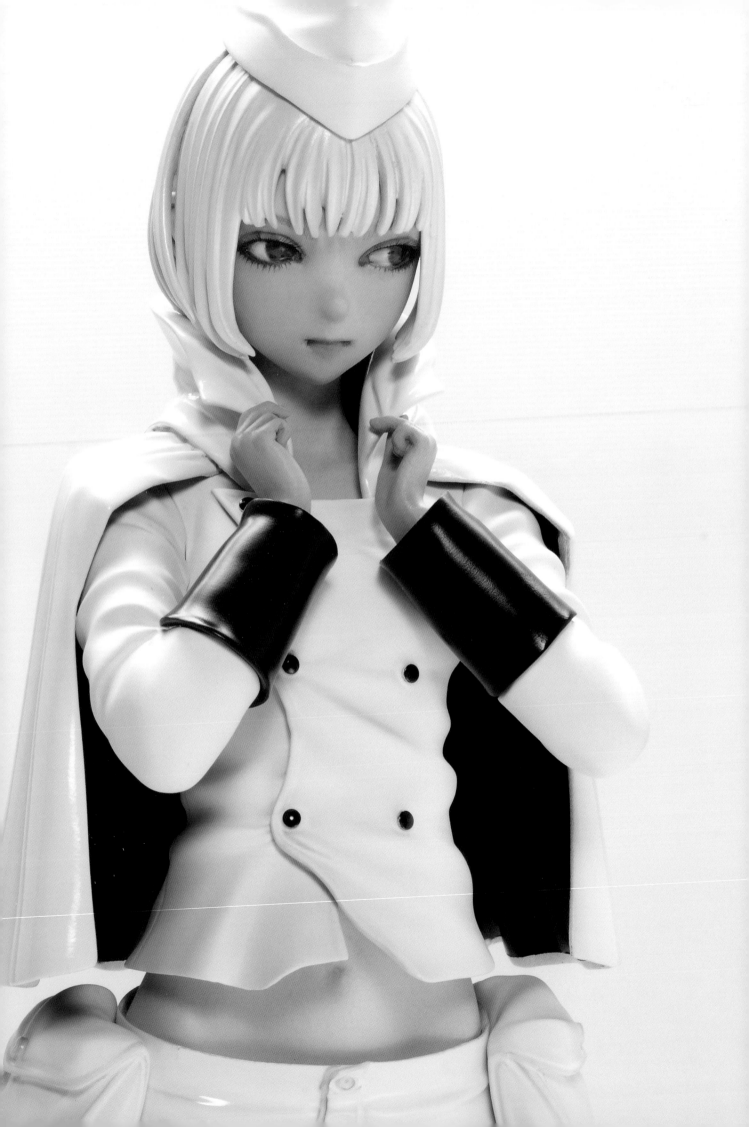

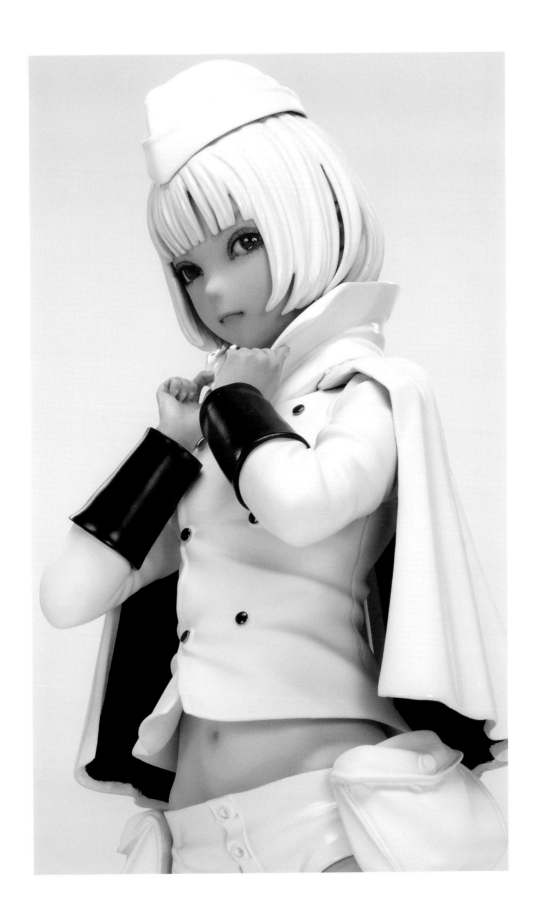

11

Erde
Erde

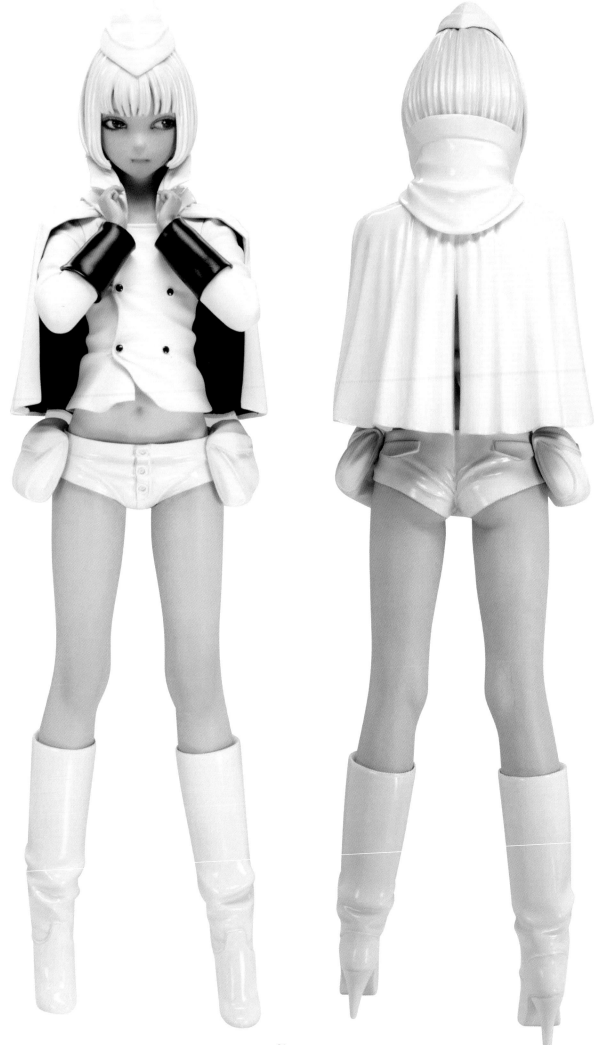

11

Erde
Erde

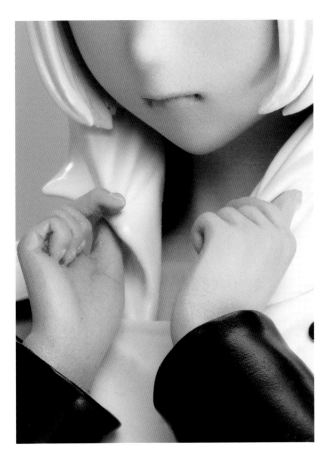

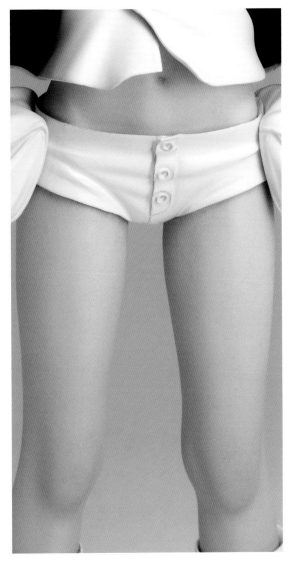

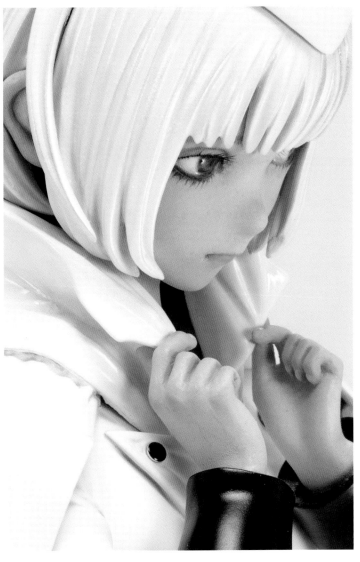

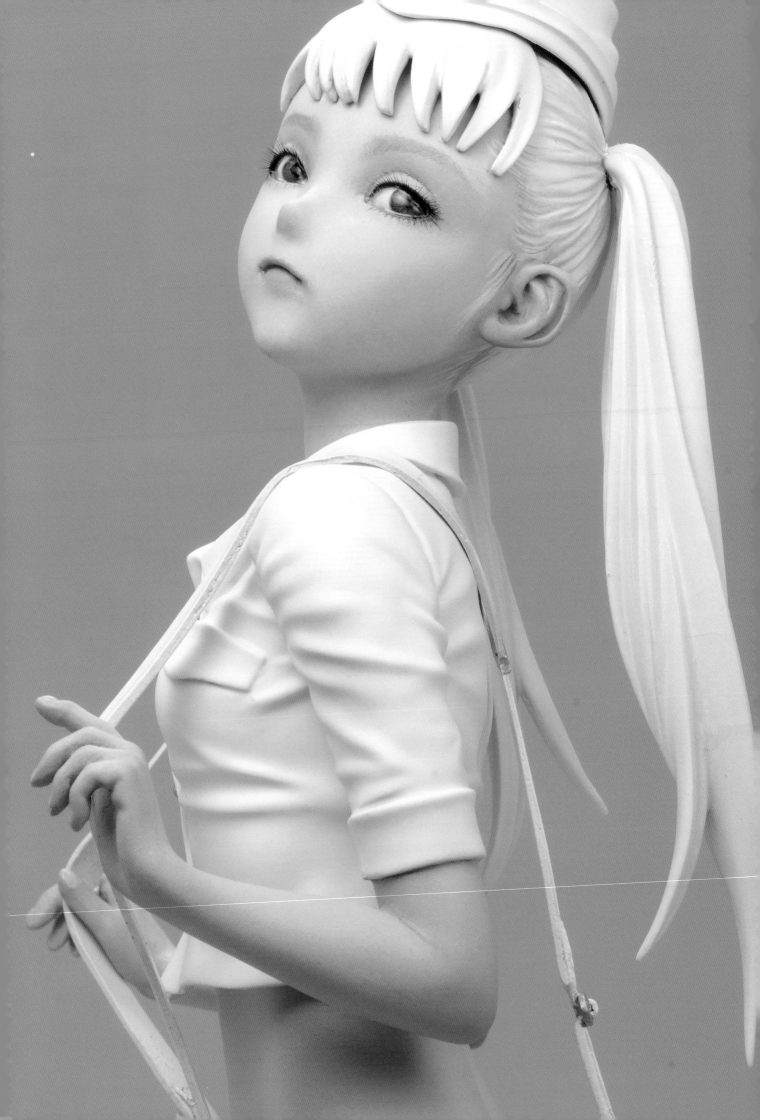

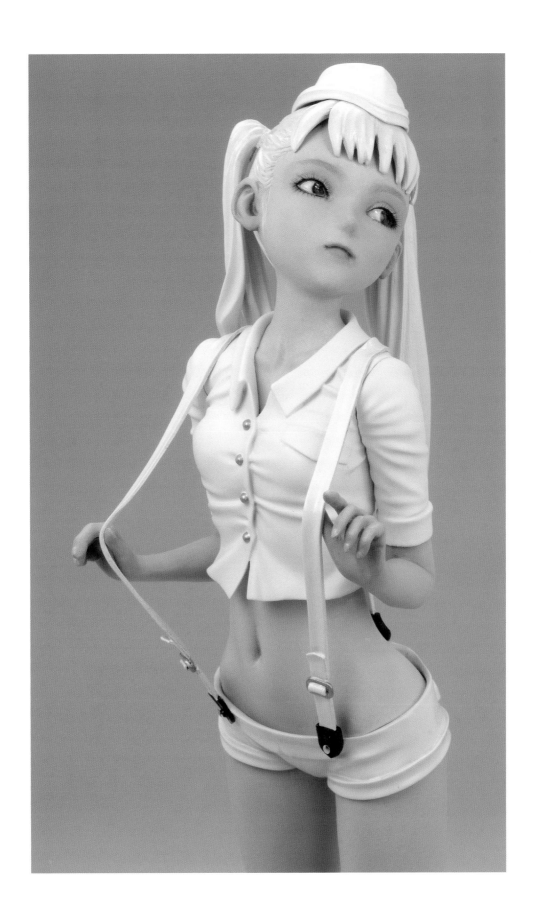

12

Soil
Soil

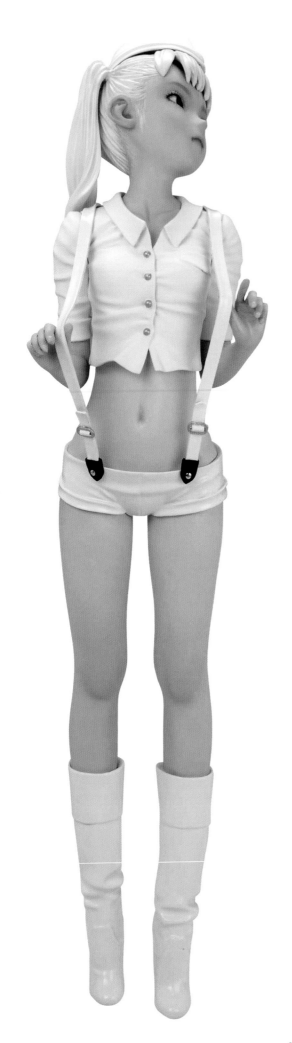
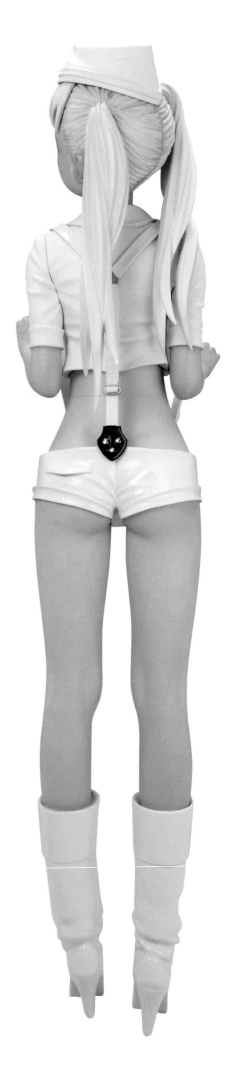

12

Soil
Soil

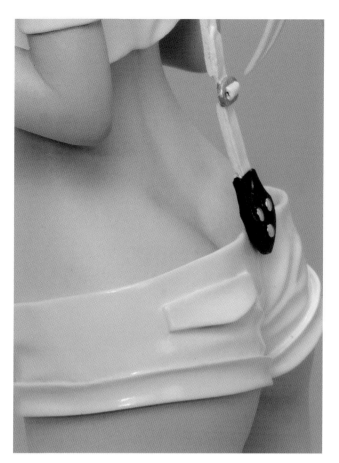

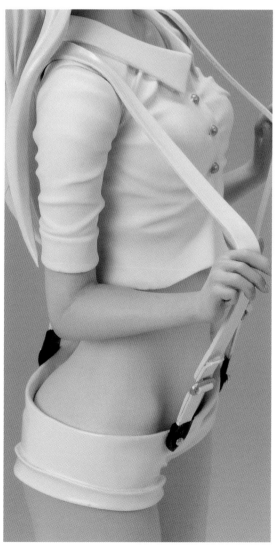

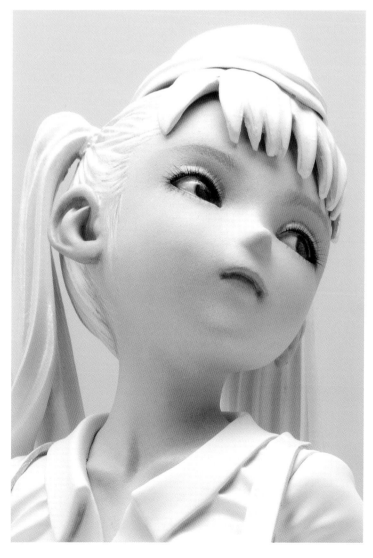

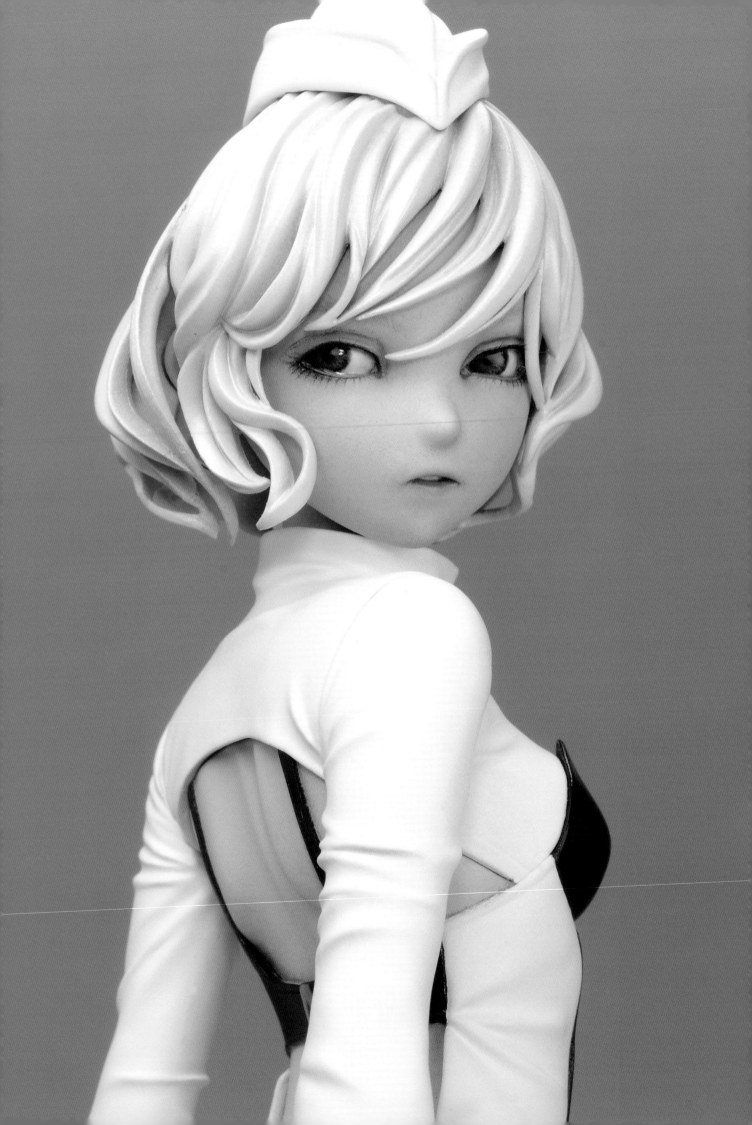

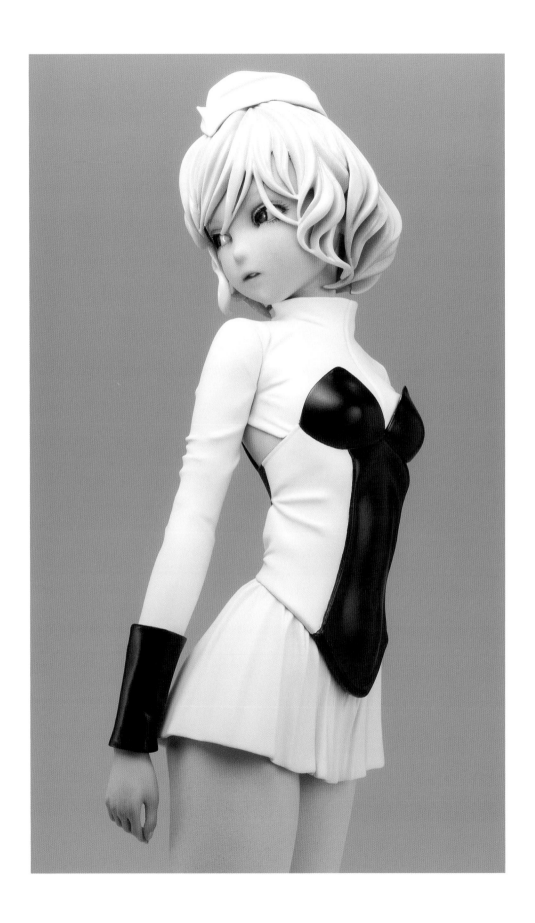

13

Luce
Luce

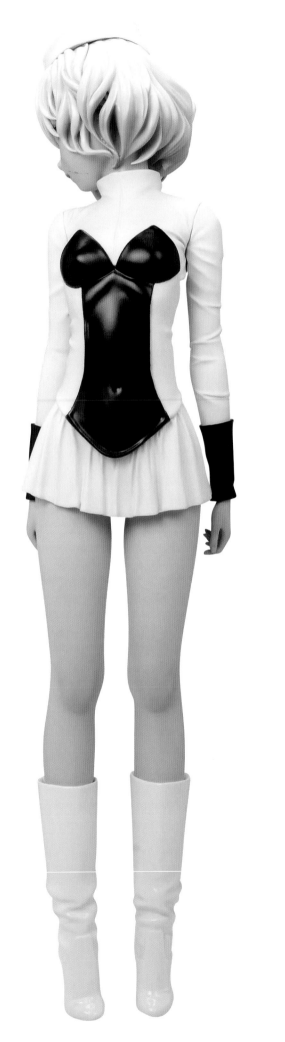
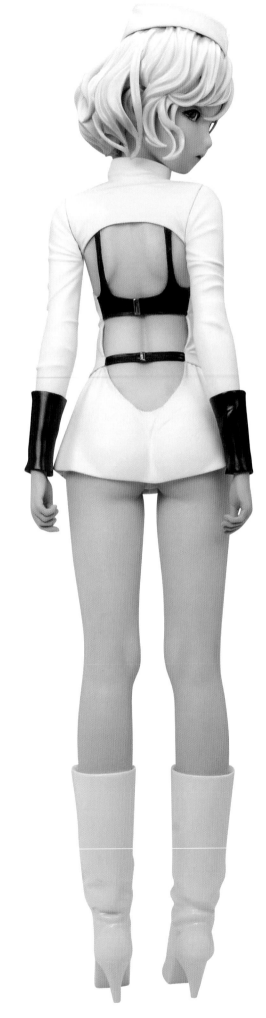

13

Luce
Luce

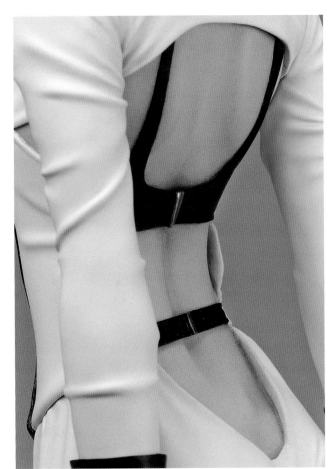

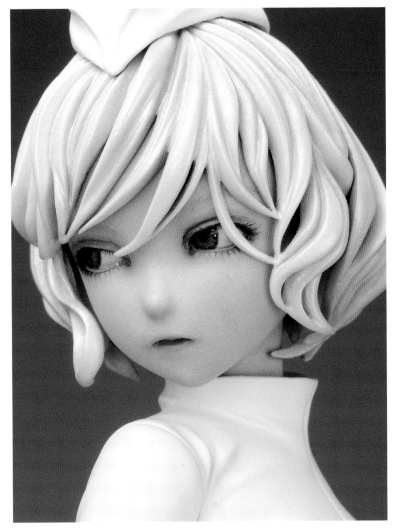

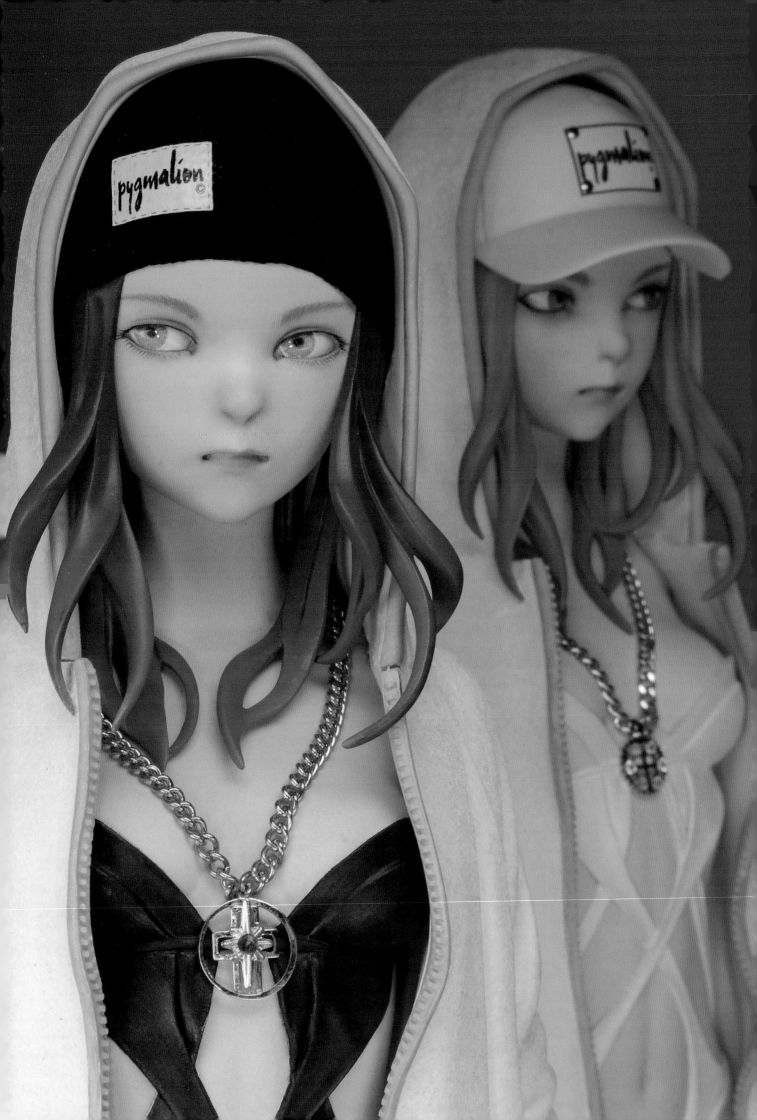

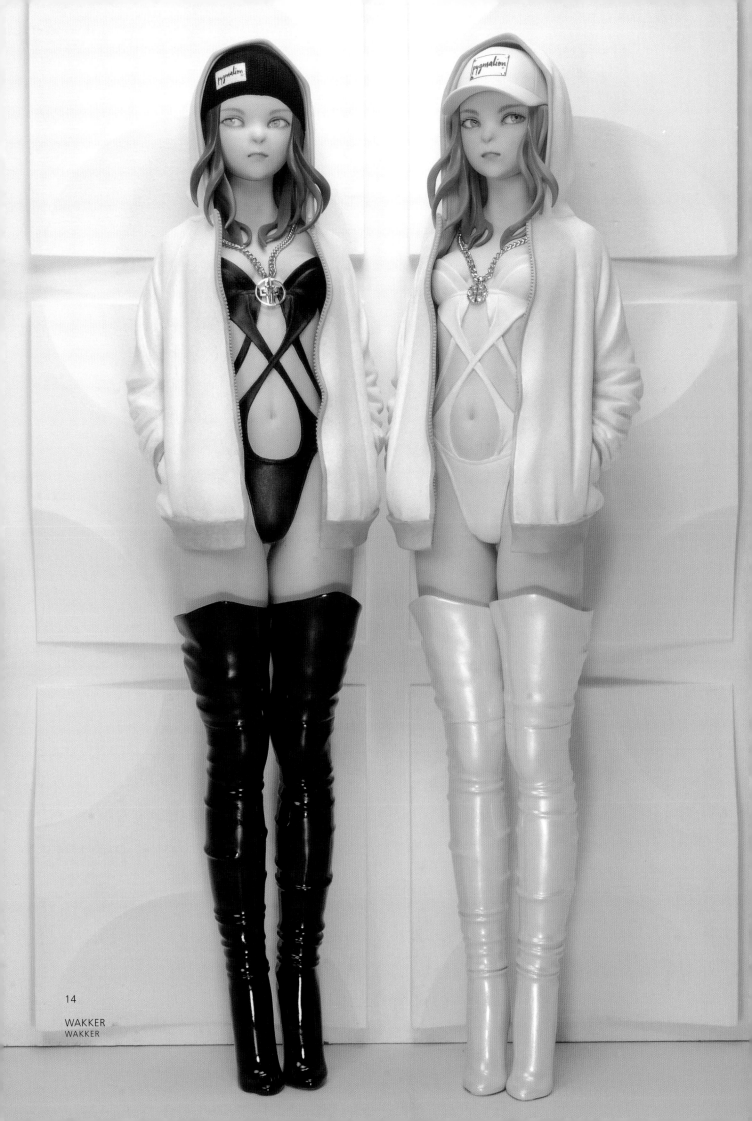

14

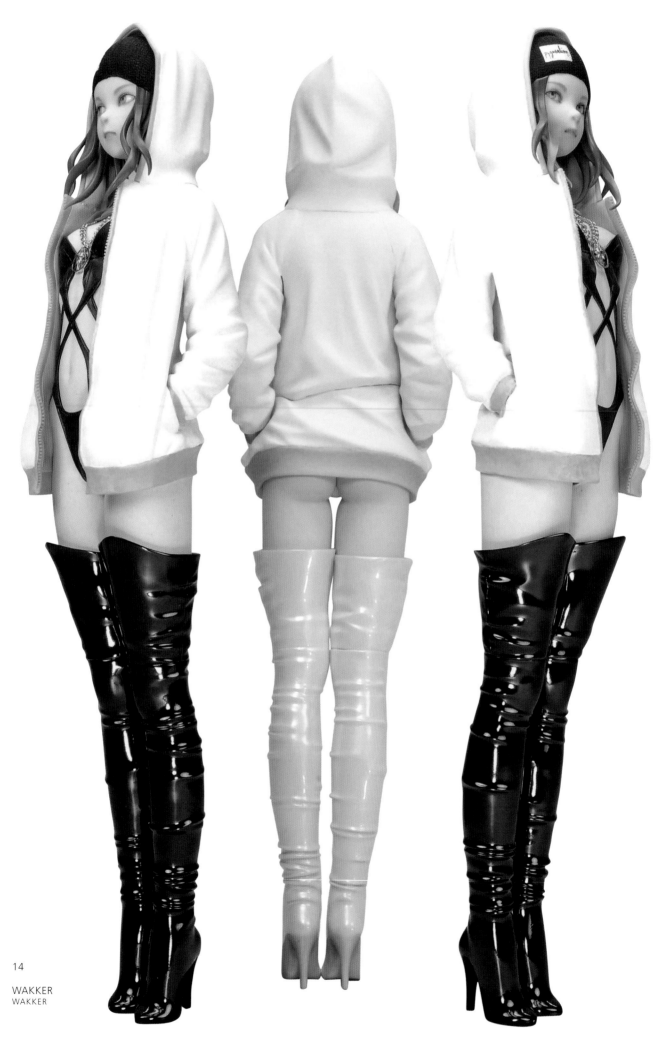

14

WAKKER
WAKKER

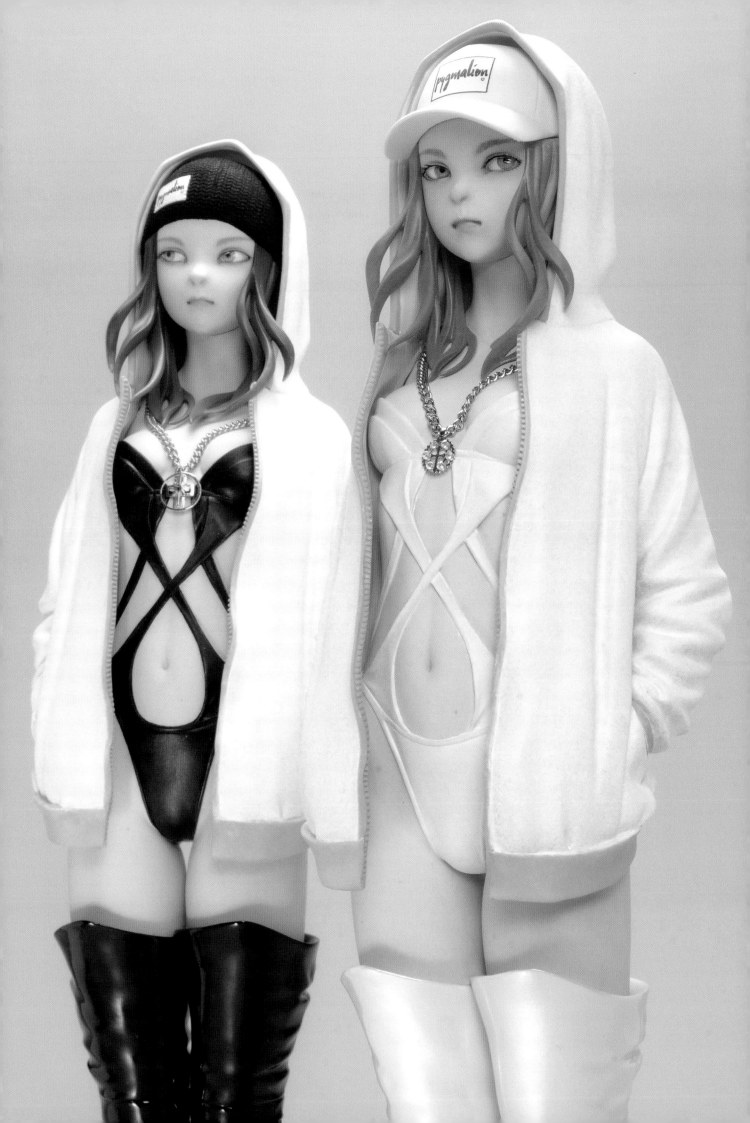

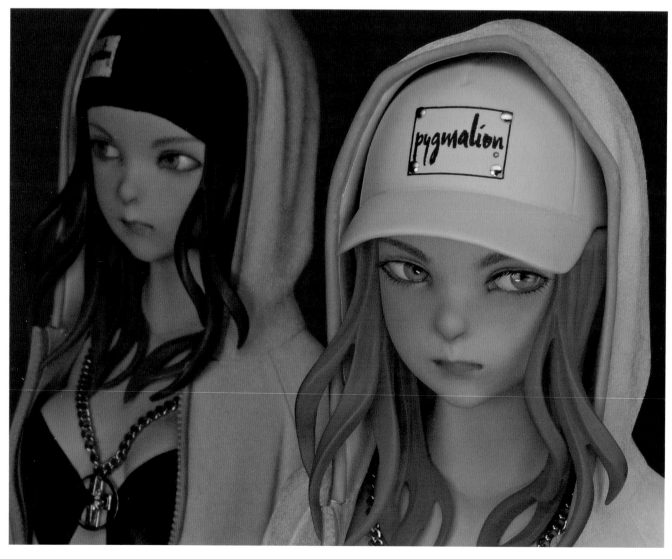

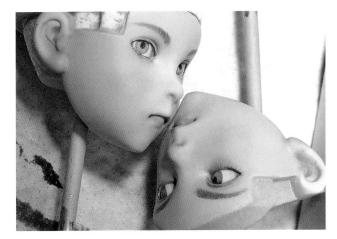

klondike原型作品
klondike's Sculptures

klondike的作品風格獨特，稍微不同於所謂的擬真類創作，呈現出田川弘自幼喜愛的古典娃娃和創作人偶的氛圍，看似毫無生氣卻又栩栩如生。

There is something unique about figures created by klondike. Rather than being typical "realistic" figures, they have a small remanence of antique dolls which Tagawa has loved since he was a child. You could say that klondike figures have the perfect balance of realism and simplification.

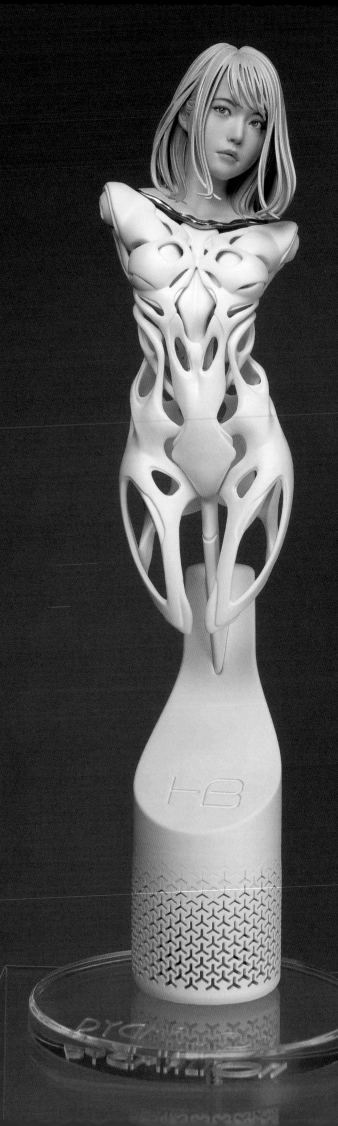

15

HB01
HB01

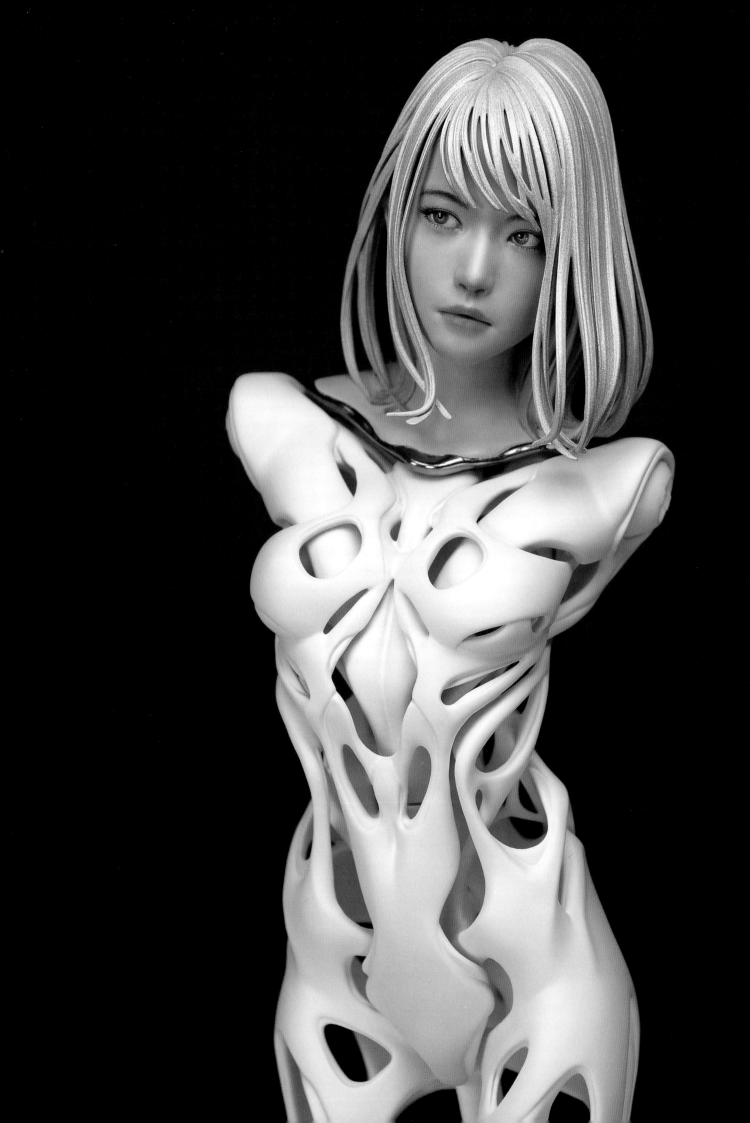

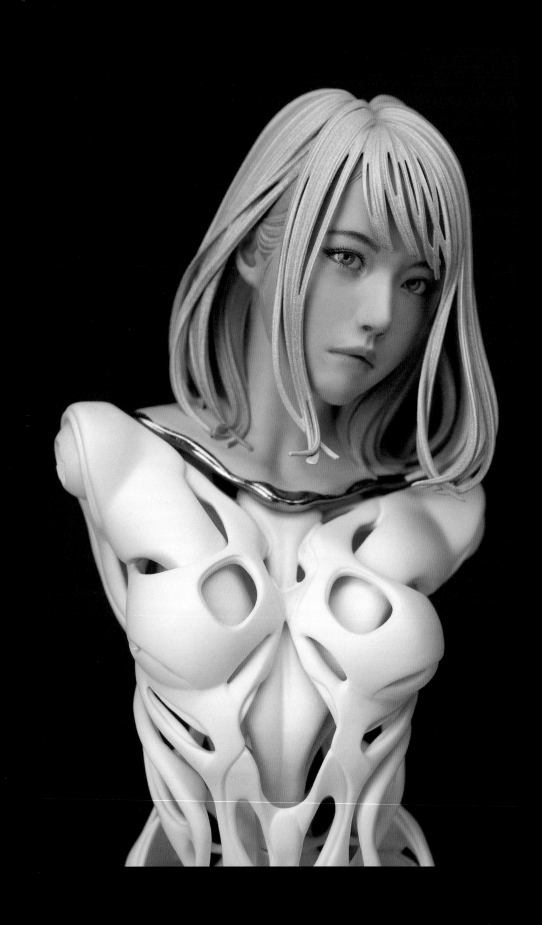

15

HB01
HB01

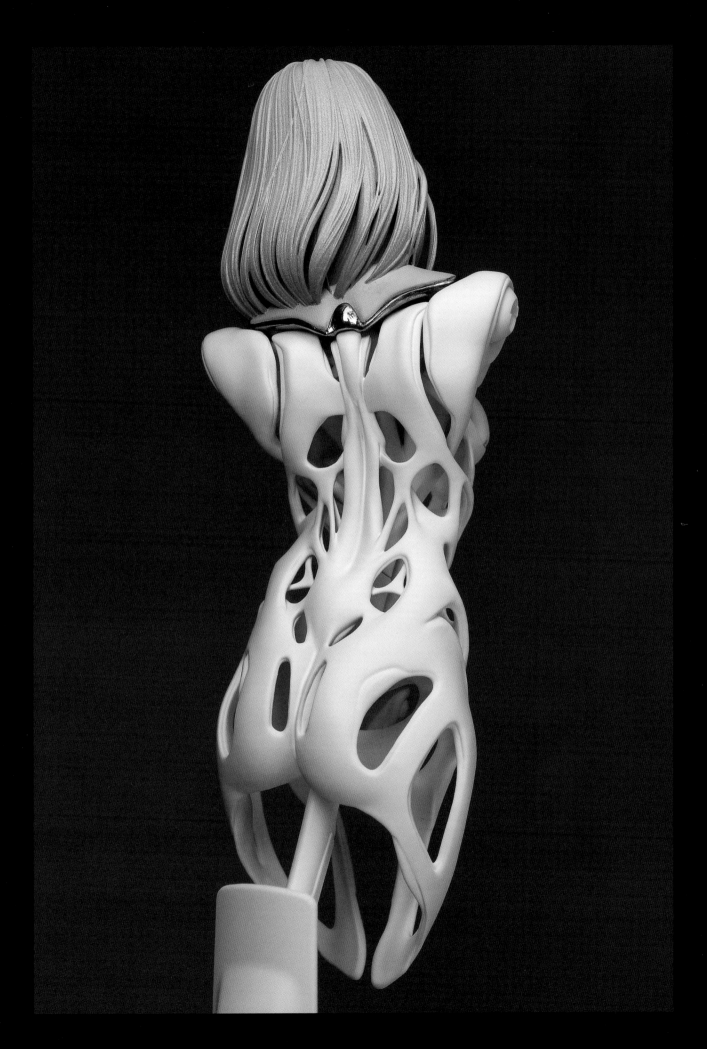

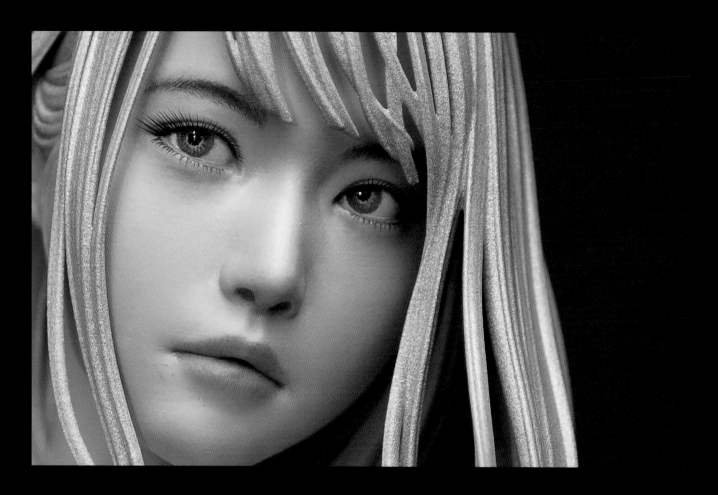

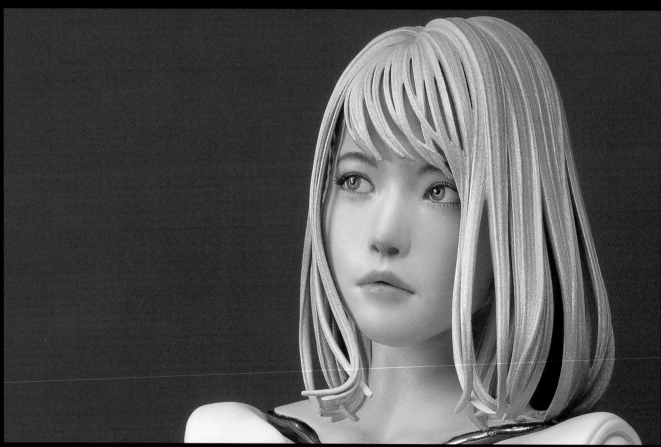

15

HB01
HB01

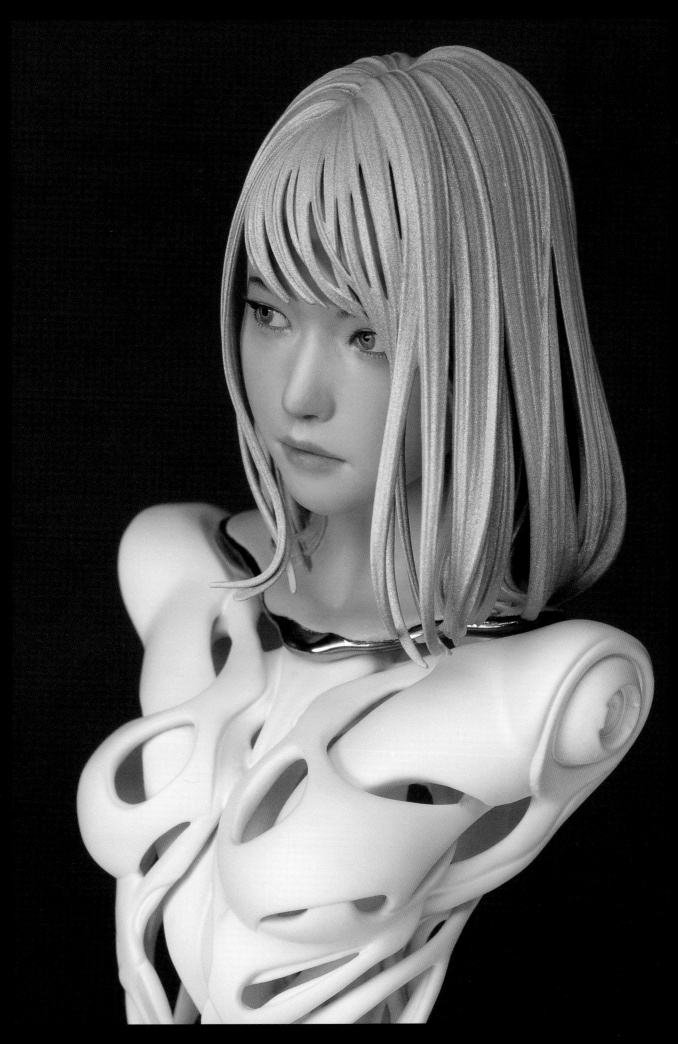

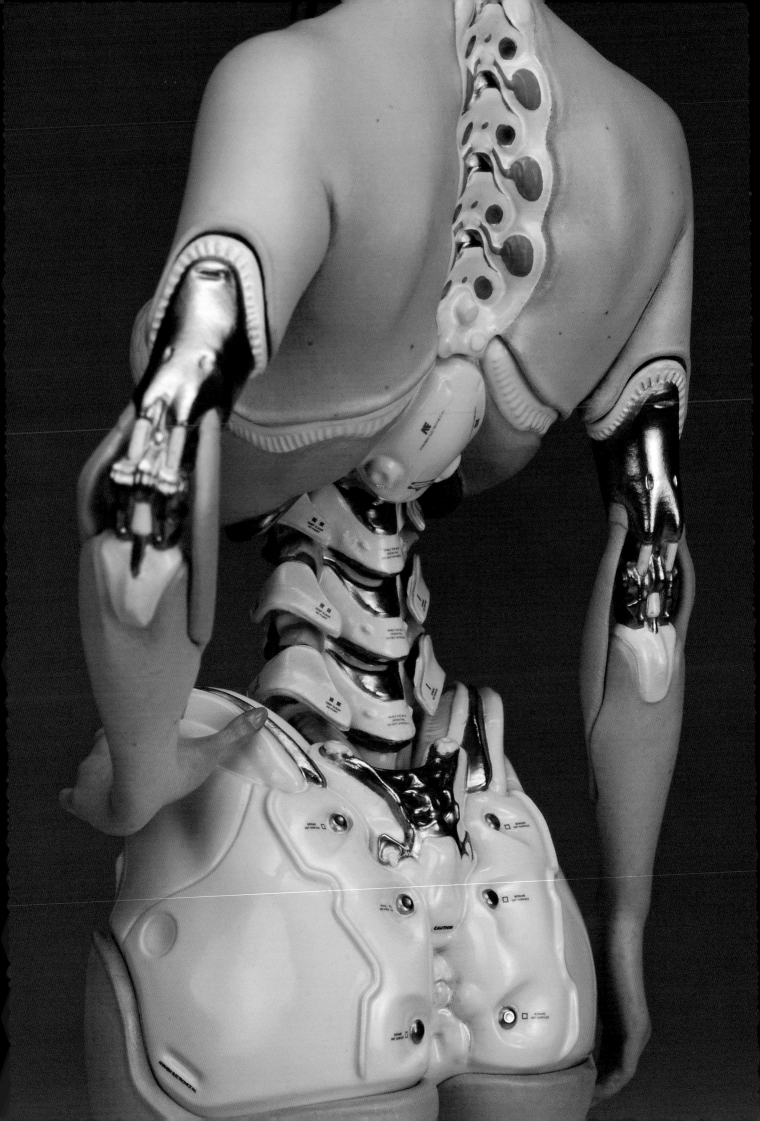

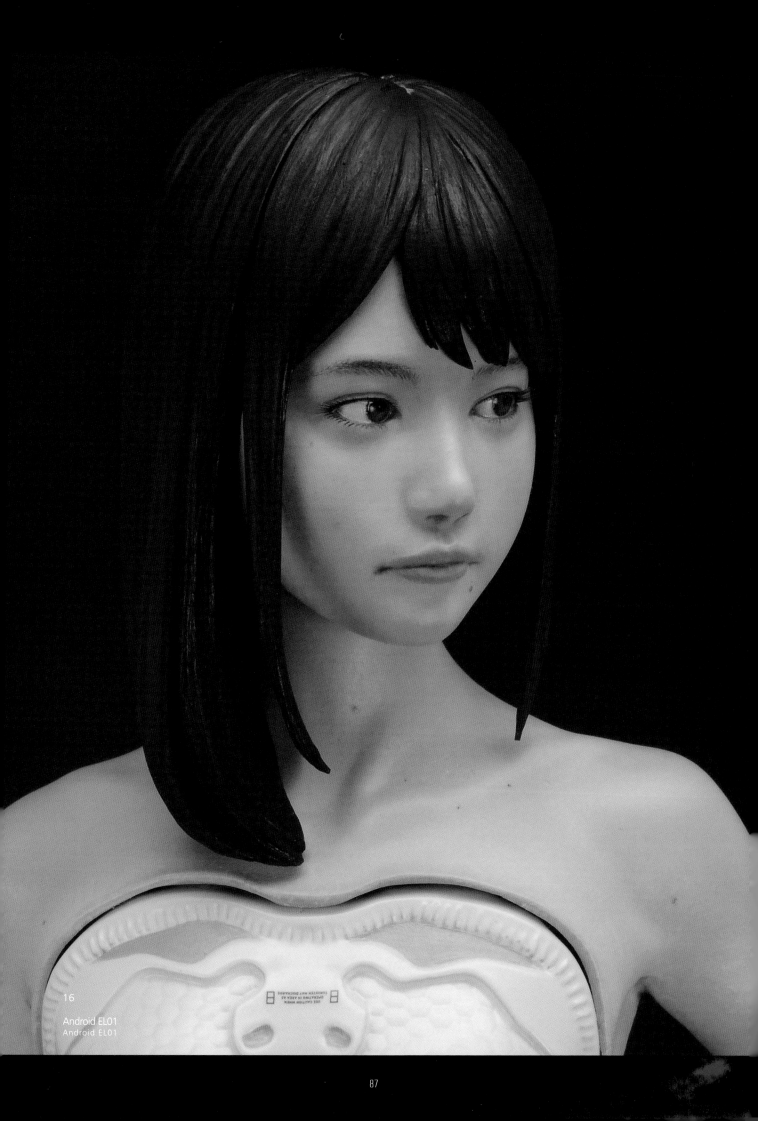

16
Android EL01
Android EL01

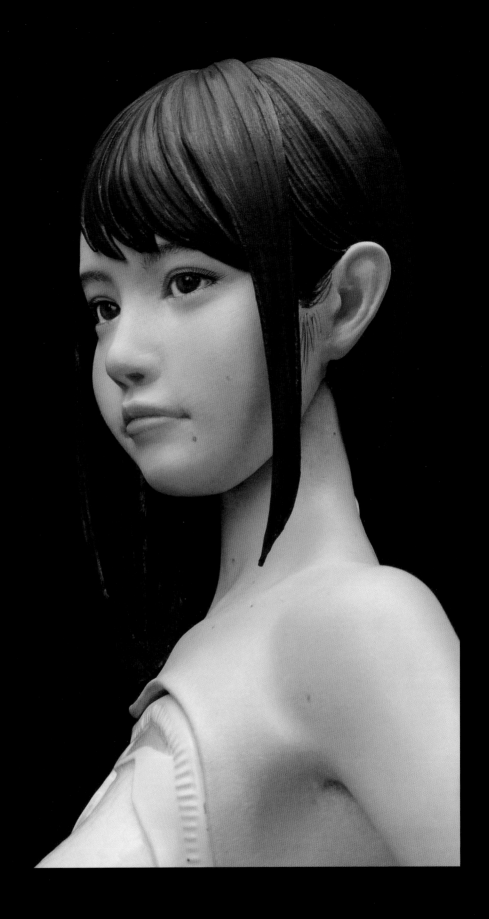

16

Android EL01
Android EL01

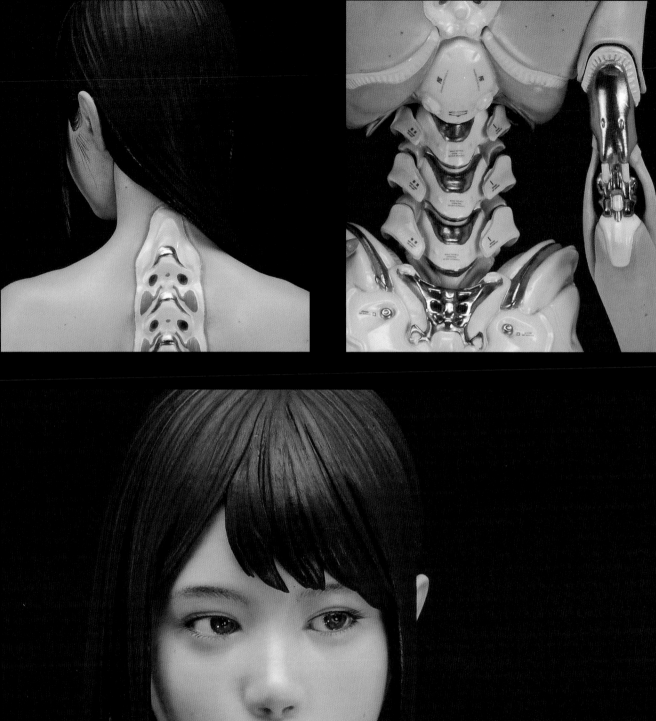

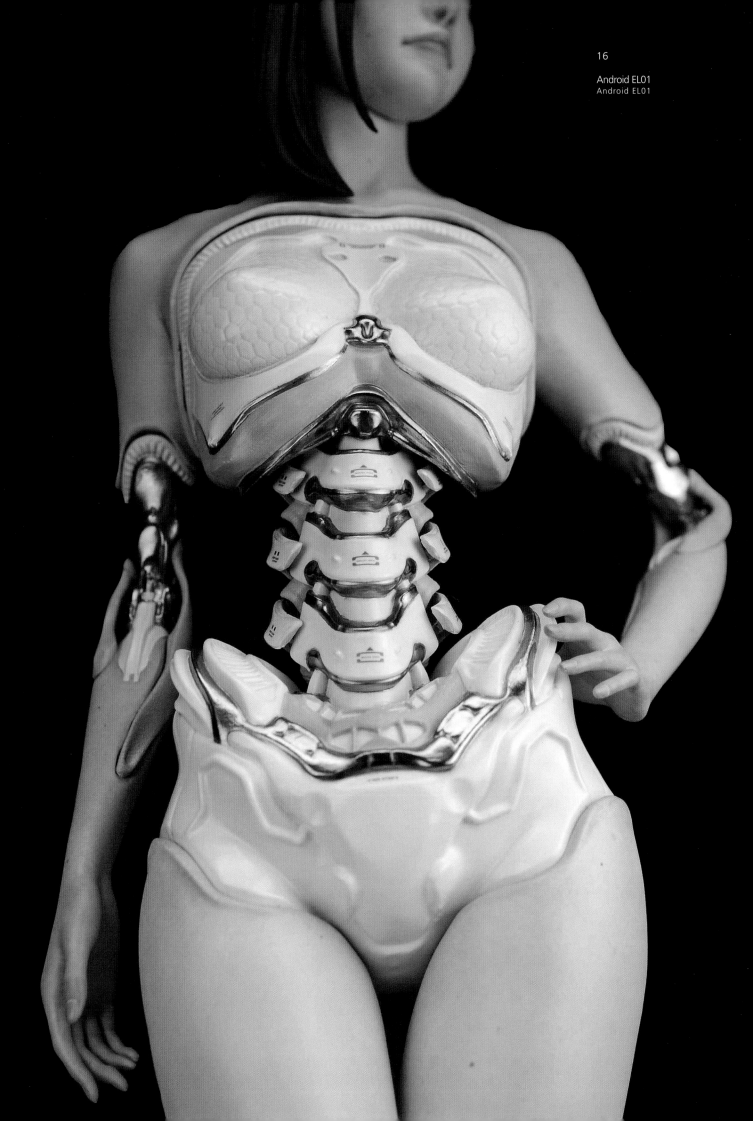

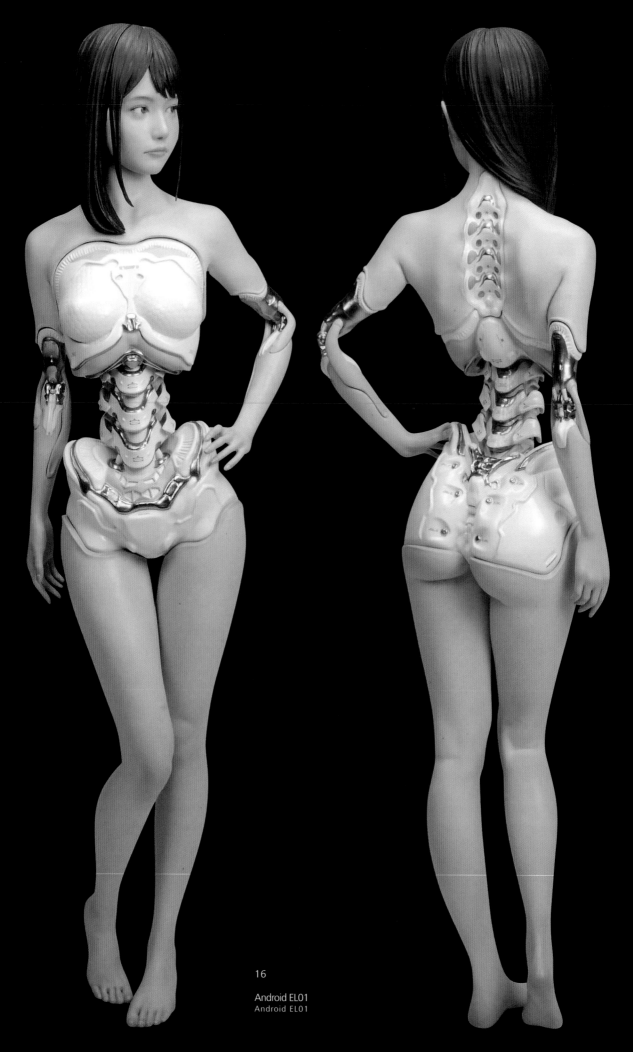

16

Android EL01
Android EL01

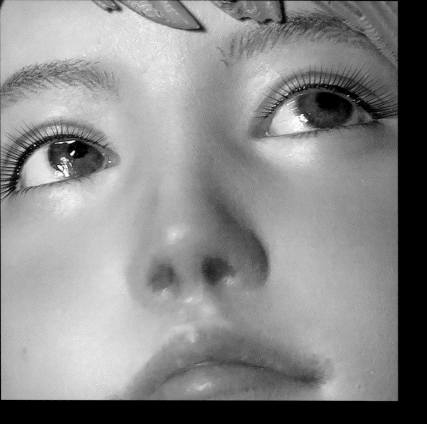

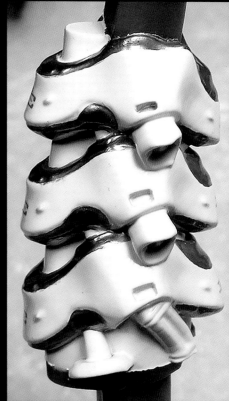

K 原型作品

k's Sculptures

K的作品主題豐富多元，富饒樂趣，不過田川弘卻笑說，若他創作的是「完美的絕世美女」，自己就不會想要塗裝。然而他的人物模型看似隨處可見，卻「充

ke's figure sculptures are interesting in a way that they encompass a variety of motifs. Tagawa also enjoys the fact that ke's figures depict imperfections in beauty. They look as if she could be anywhere in real life yet remains attractive. That is why Tagawa greatly

看待田川弘作品的方法

Facing Tagawa's works

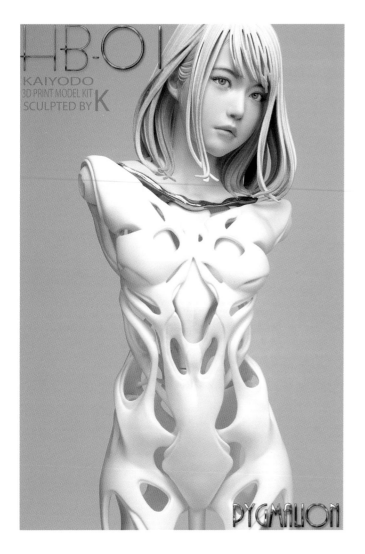

收藏於「平面」的作品

Composition in Two-Dimension

因為人物模型是立體作品，田川弘原本就喜歡為成品塗裝修飾。然而慢慢上傳至社群平台之後，有越來越多人開始欣賞他的作品。在拍攝作品的過程，他開始留意照片的構圖、照片的文字搭配、排版和照明等。如此一來，上傳供大家欣賞的照片，透過將立體拍攝成圖像，提升成自己最想表現的作品角度。自己的塗裝不但是獨一無二的立體作品，還成了讓大眾欣賞的平面創作。兩種創作的關係不同於繪圖與畫冊，不論何者都是「依照田川弘構思所描繪的形象」。

Since figures are three-dimensional sculptures, Tagawa used to back in the afterglow by displaying them after completion. However, his works gradually caught the attention of more and more people through social networking services and other online media outlets. Tagawa begun paying more attention to photographing-aspect of the whole process, taking extra time planning the background, composition, and lighting. Photos, which is two-dimensional, has the benefit of limiting viewers with set angle. This way, Tagawa can capture and present his figures in their most desirable line of sight. While figures painted by Tagawa are one and only, his two-dimensional theater is most definitely part of his work.

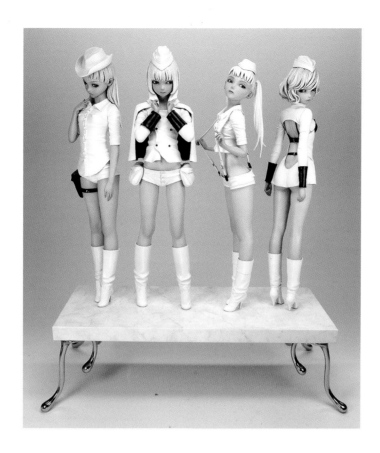

對基底和展示台的講究

Attention to the base and display stand

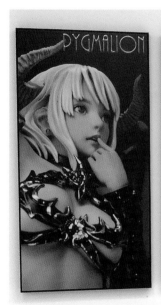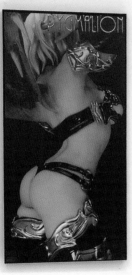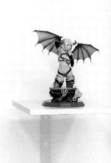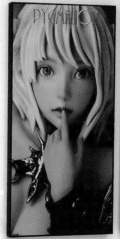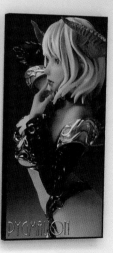

田川弘過去都以木質展示台展示單件作品，然而近年改以厚約10mm的透明壓克力板展示，並且只刻上「PYGMALION」的字樣。在他不斷創作的期間，「最希望大家聚焦於人物模型本身」的想法越來越強烈，例如：即便原本是為了呈現某個情景的模型，也刻意不做出情景基底，而只完成單件人物模型。他認為就算只在腳邊放上一顆石頭或一朵花，都會干擾觀眾關注的視線，而只想用人物表情、指尖、眼神、膚色表現自己創作的情感、她們的世界和整體氛圍，因此連展示台都成了省略的部分。

In the past, Tagawa has used a wooden display base for his figures. In recent years, he has preferred a simplistic approach by using a transparent acrylic board of 10mm thickness with his brand, "PYGMALION" engraved. In the end, Tagawa wants viewers to focus on his figure and figure only. Even when a resin kit includes a display base, he dares to finish the sculpture by itself. "A single stone or a single blossom of a flower is enough to distract your focus. I aim to express my emotions, their world, their surroundings, and atmosphere with just the figure itself," says Tagawa. Therefore, even the display stand is an obstruction to be taken out.

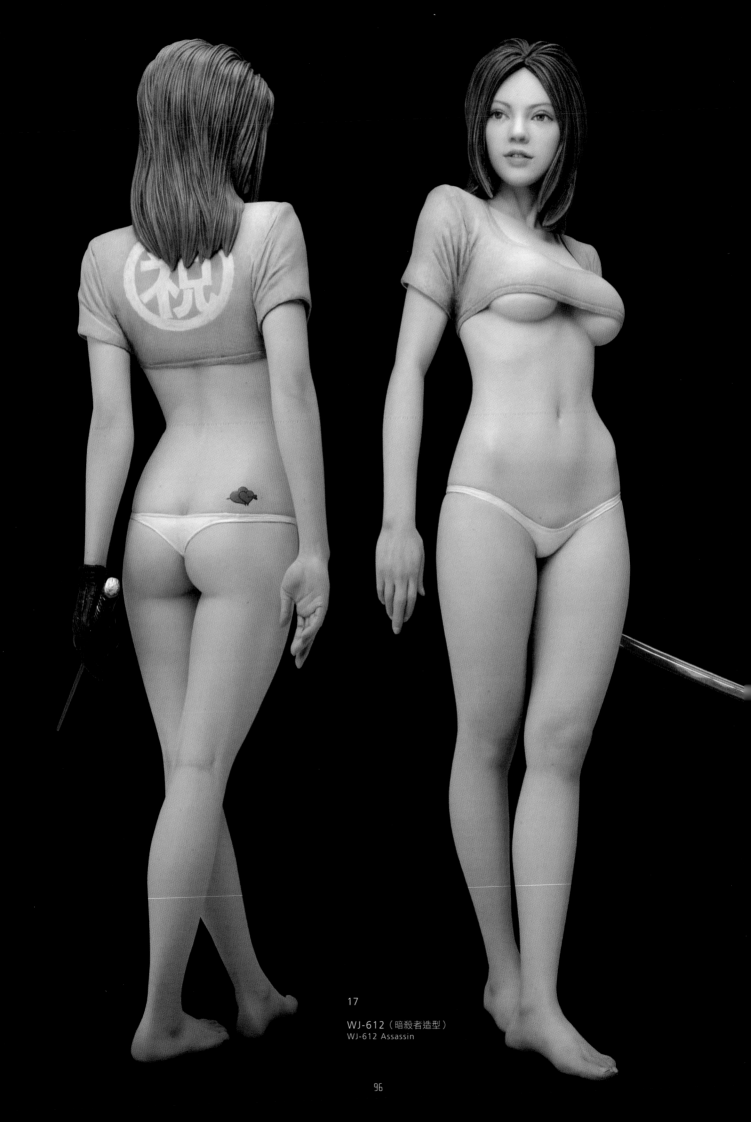

WJ-612（暗殺者造型）
WJ-612 Assassin

17

96

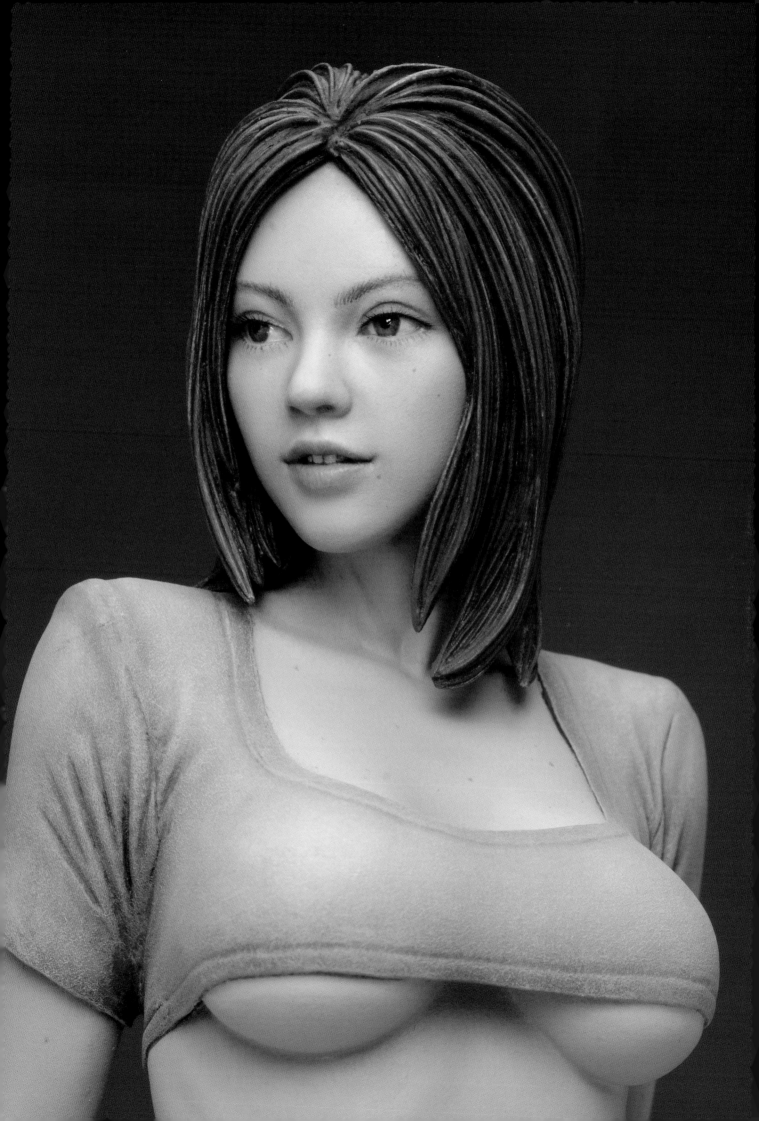

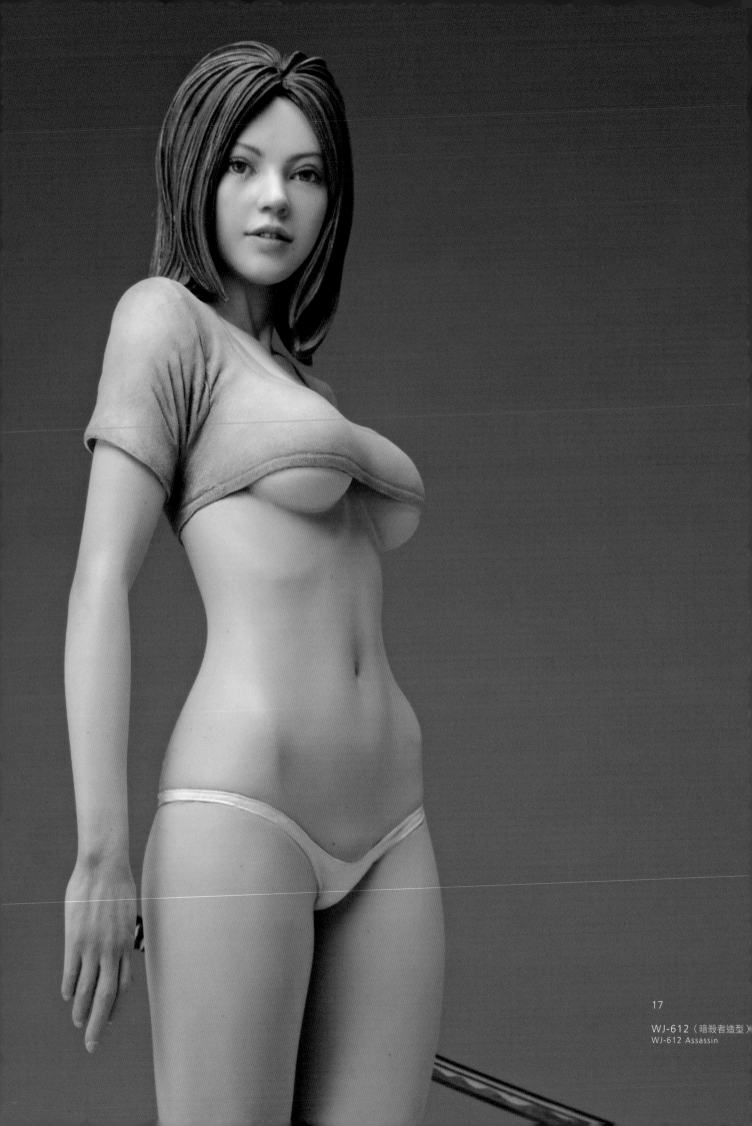

17

WJ-612（暗殺者造型）
WJ-612 Assassin

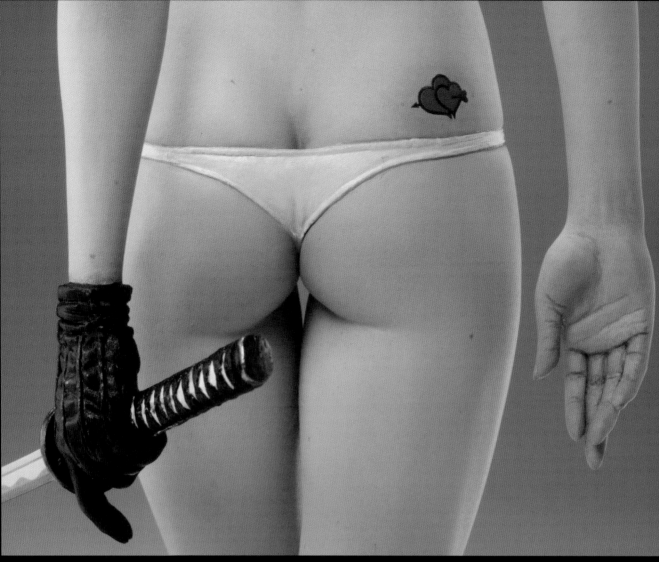

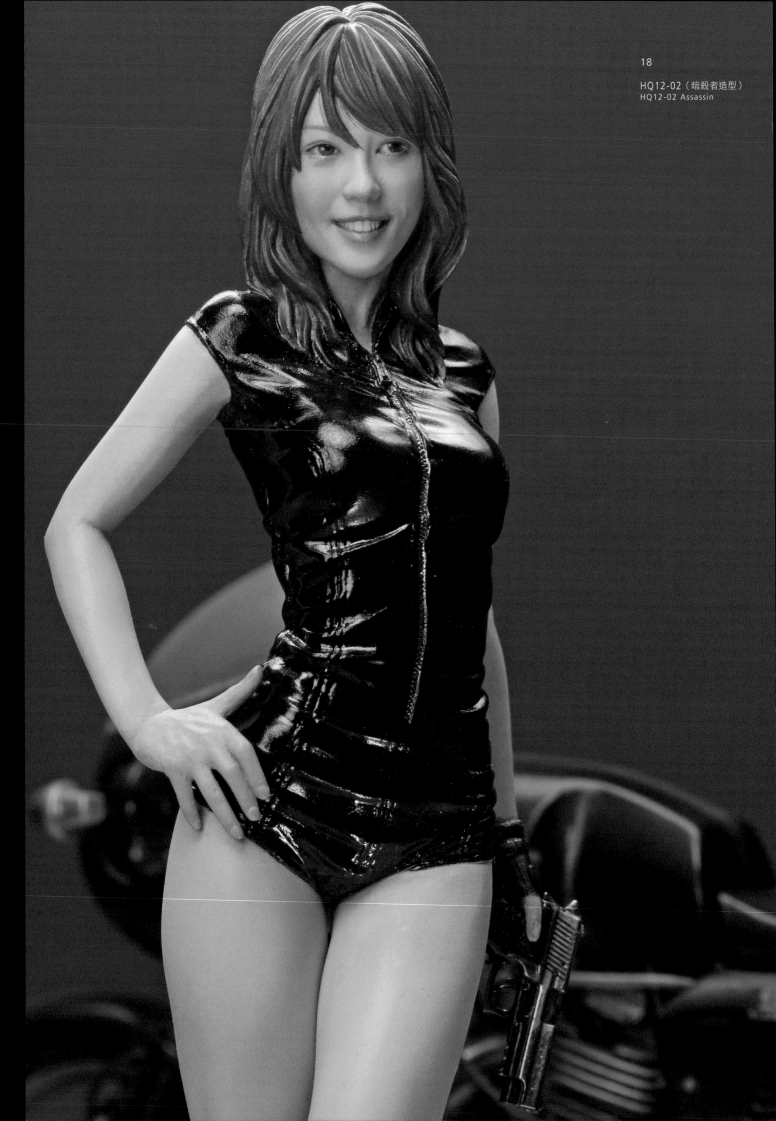

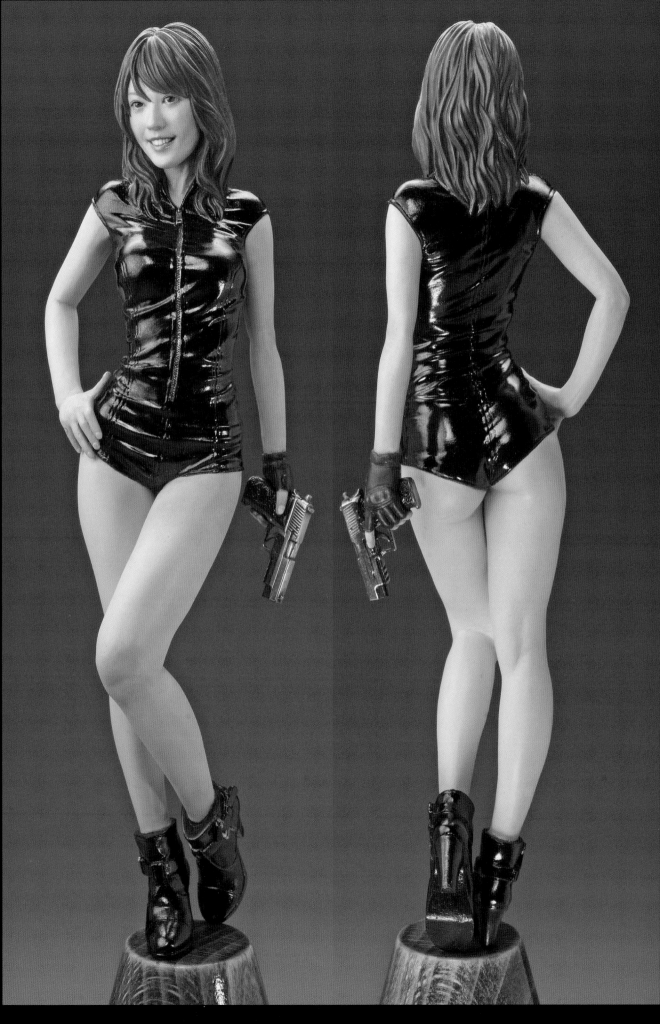

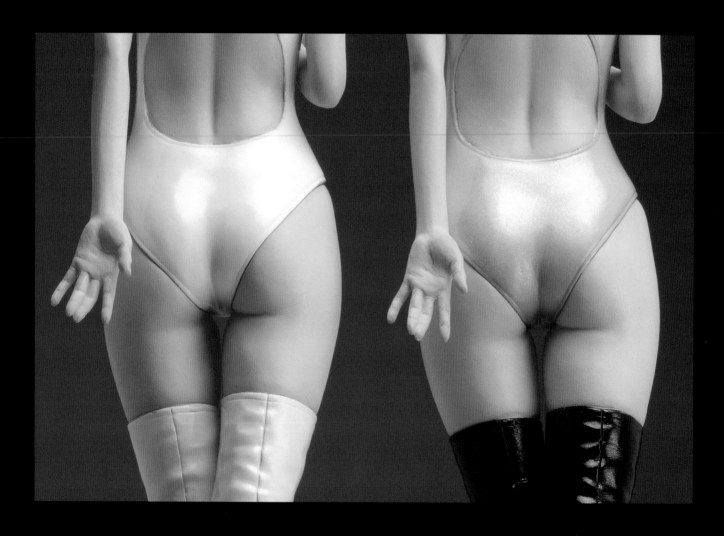

19

HQ12-05　2&3號機
HQ12-05　02&03

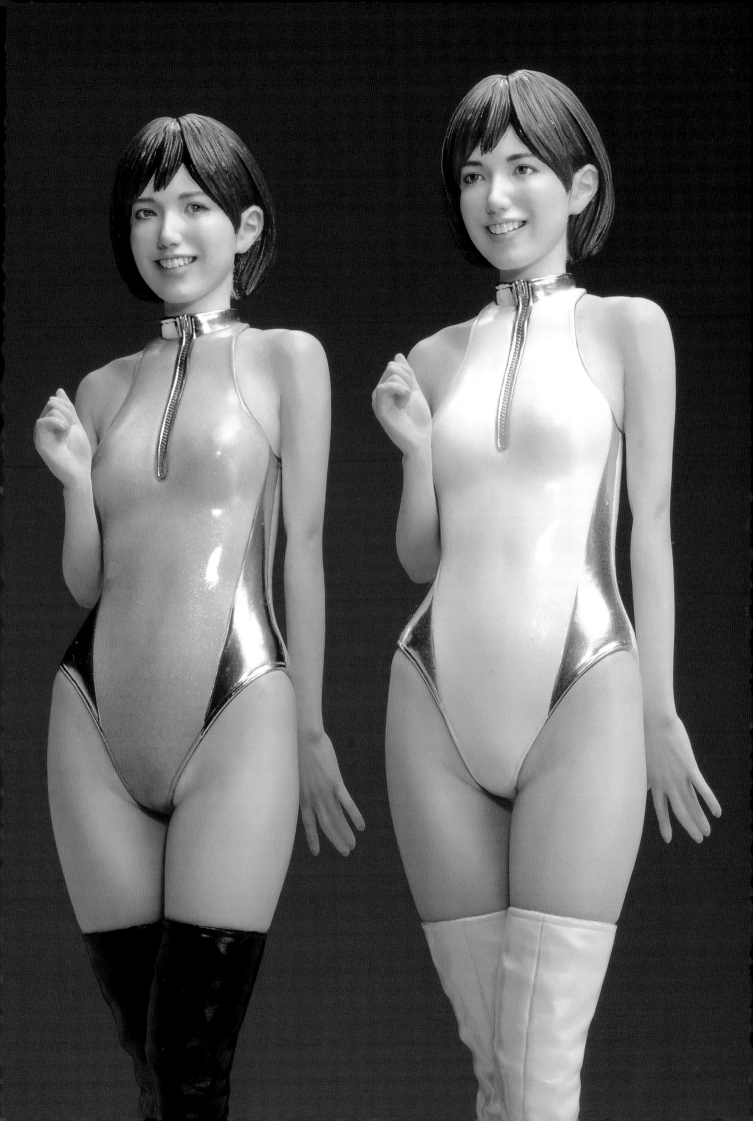

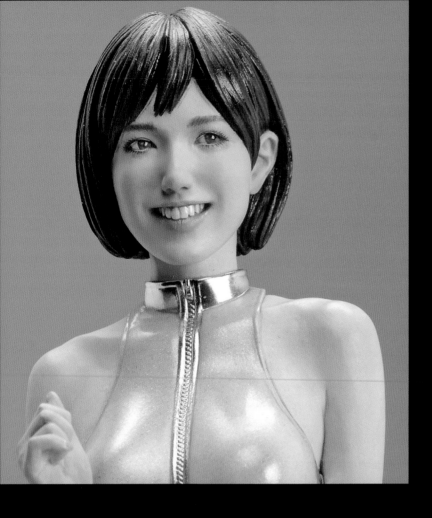

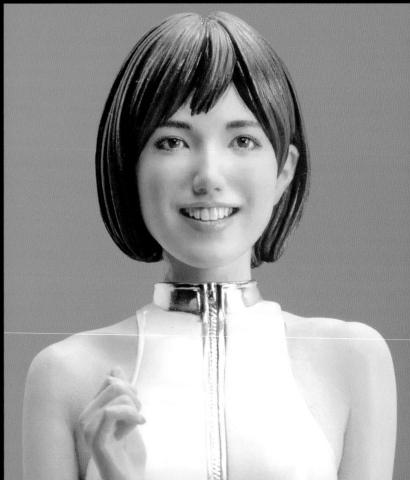

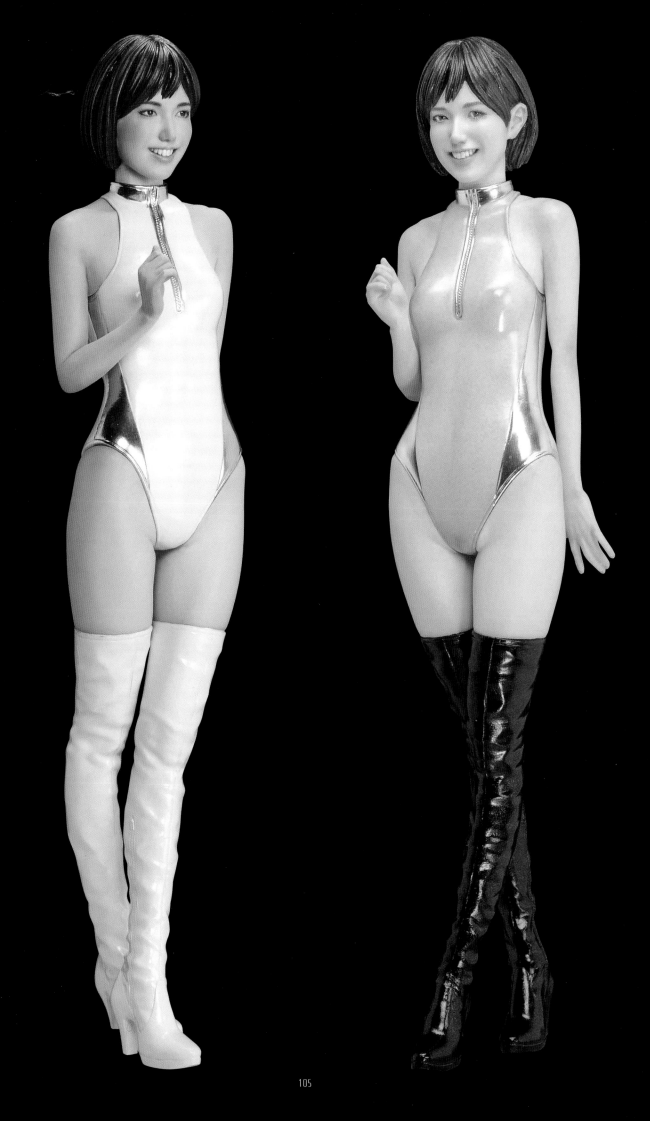

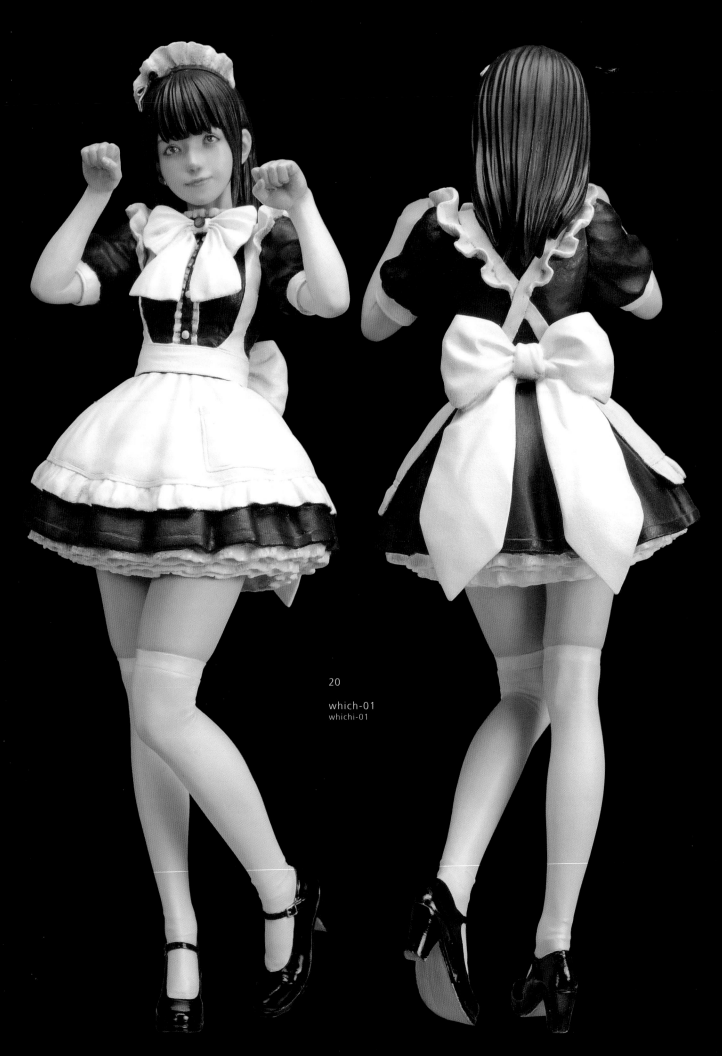

20

which-01
whichi-01

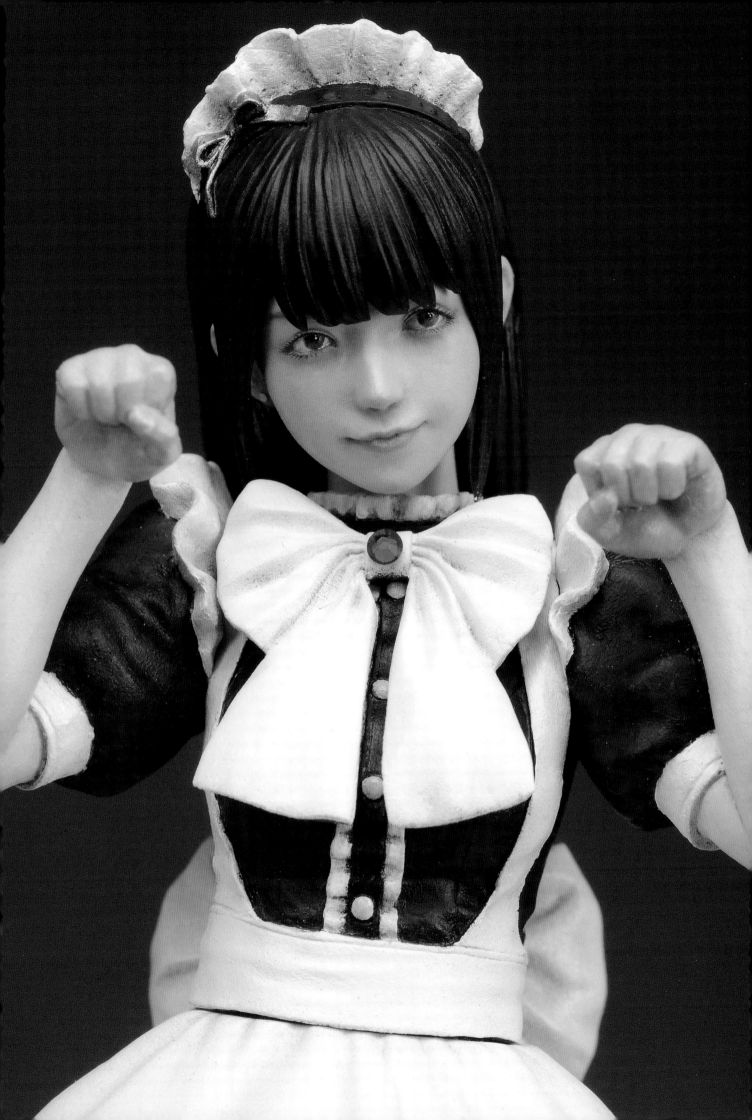

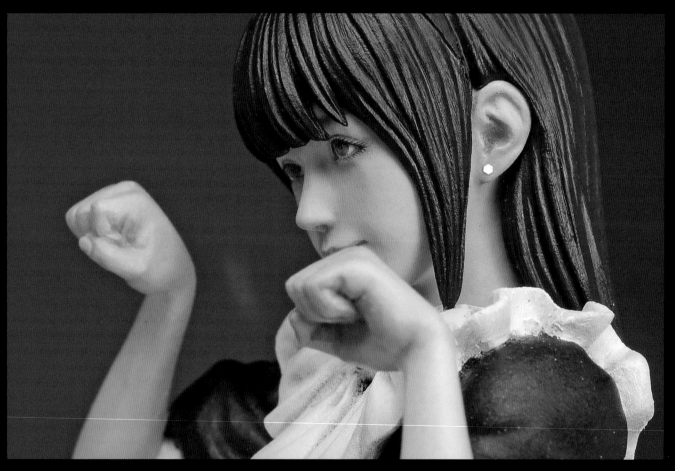

20

which-01
whichi-01

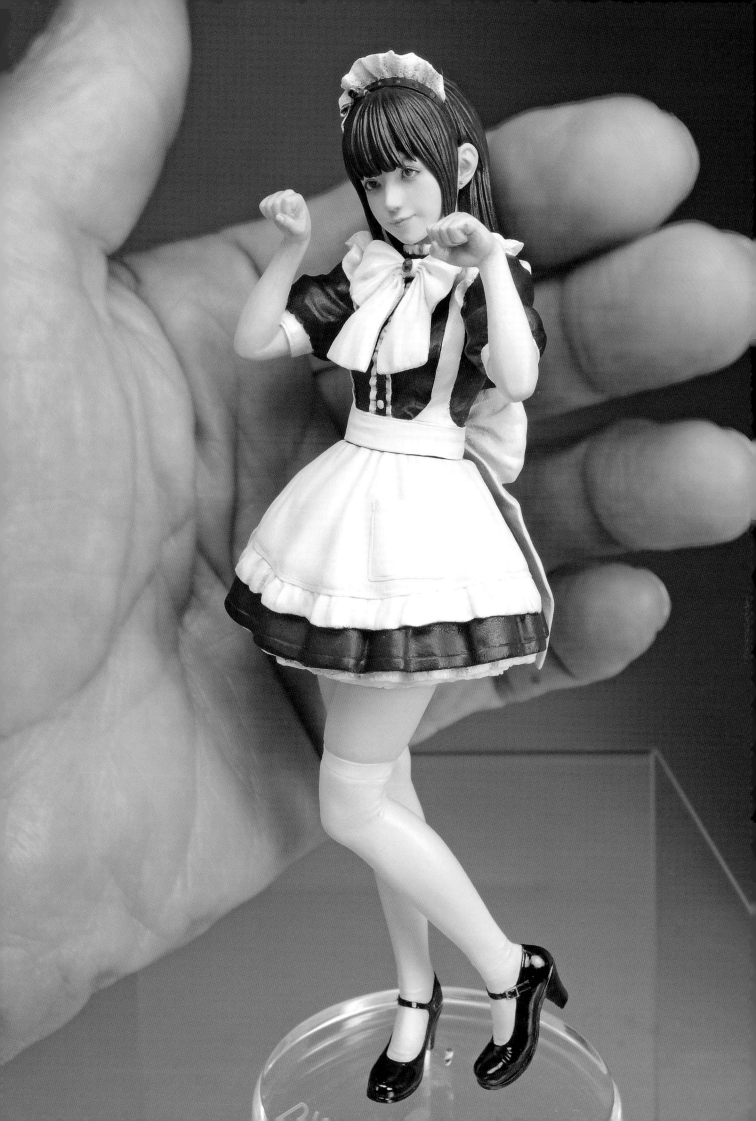

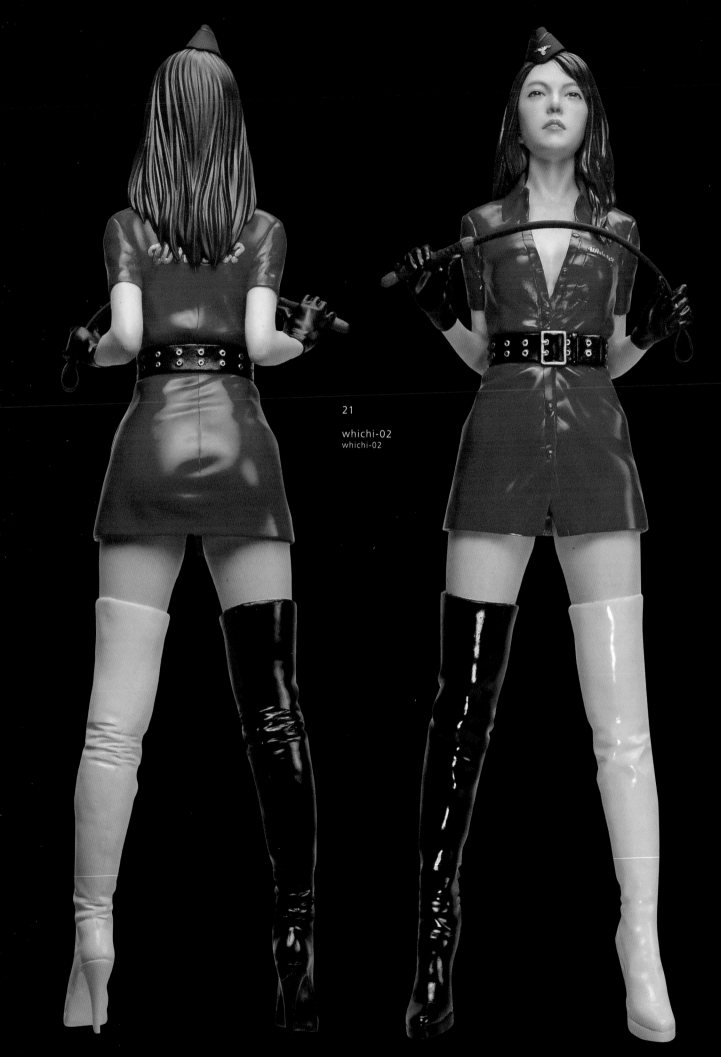

21

whichi-02
whichi-02

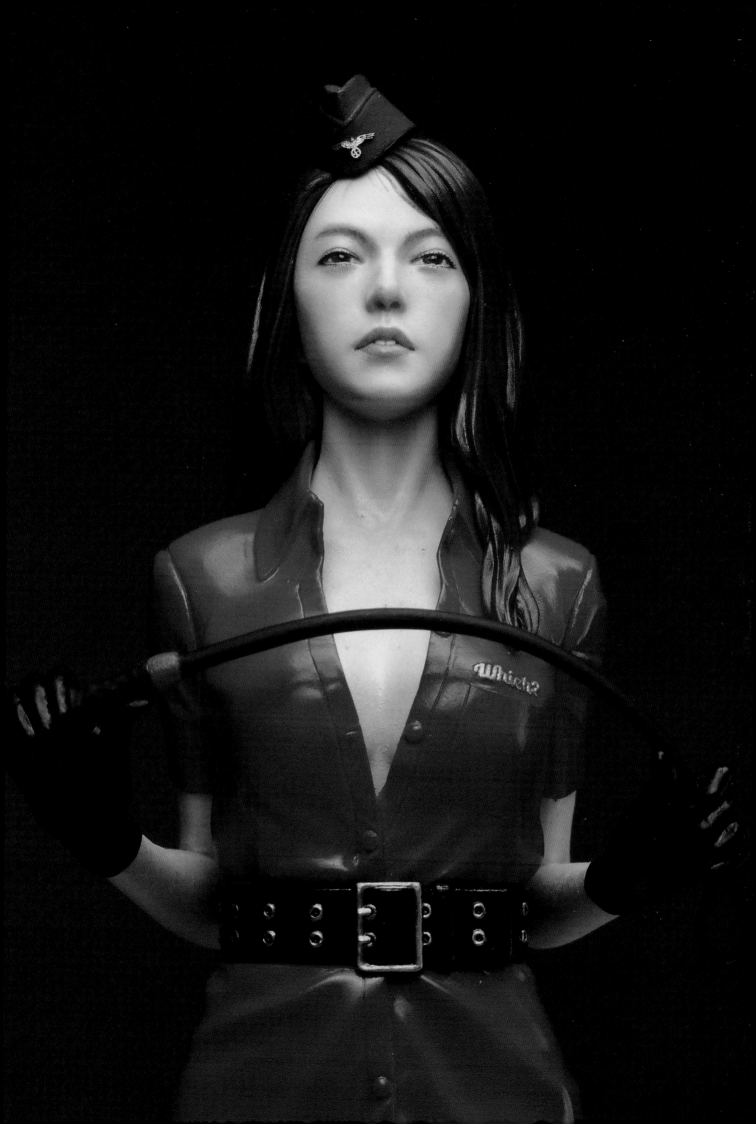

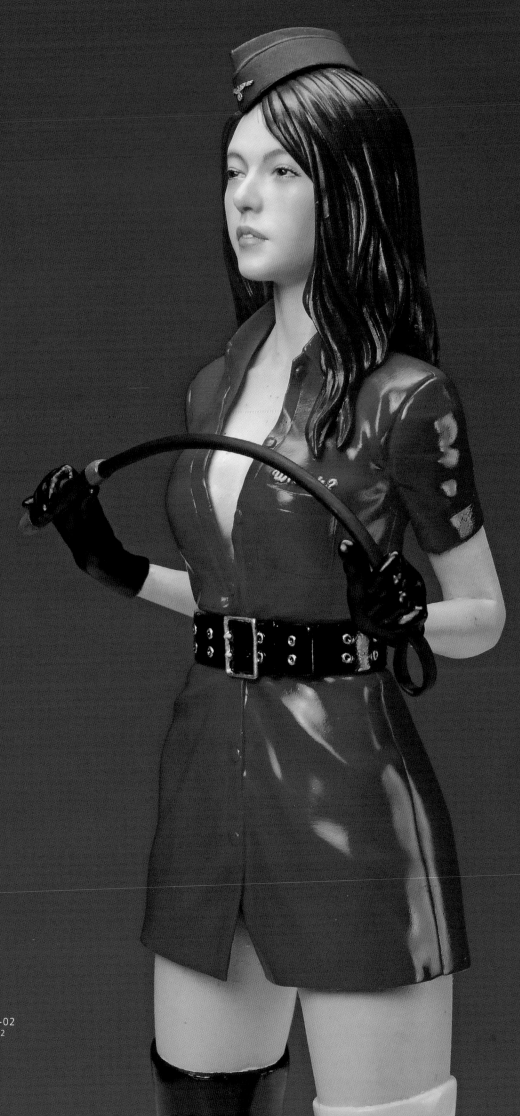

21

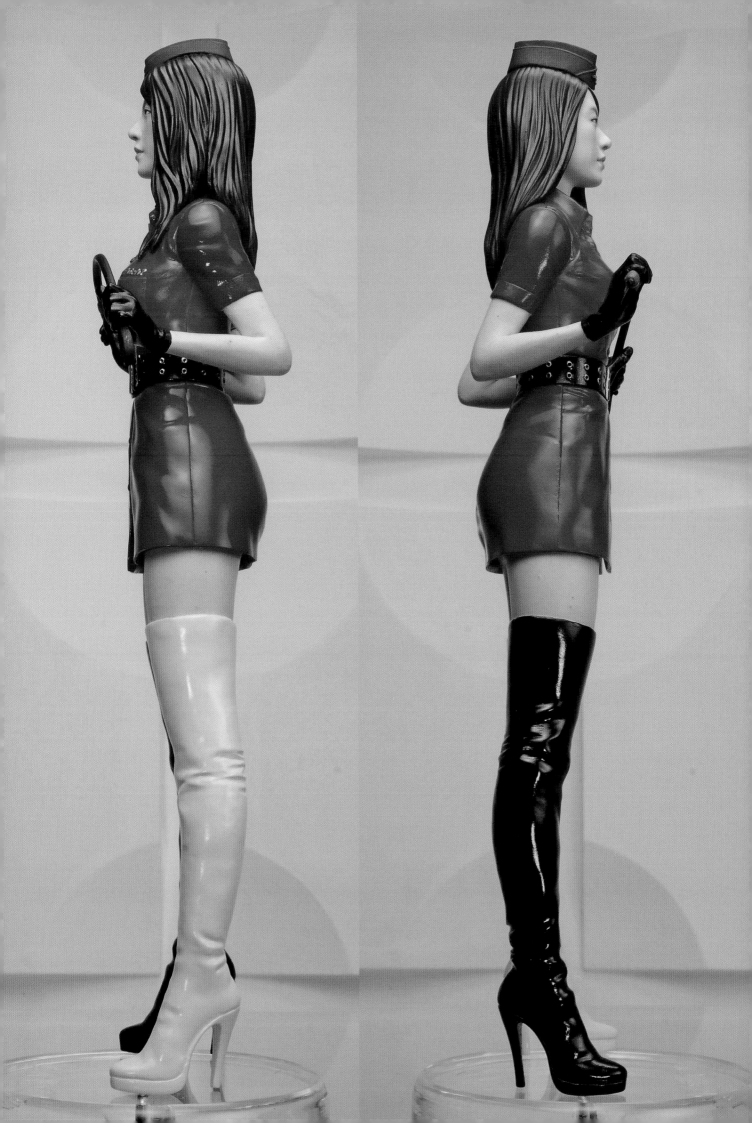

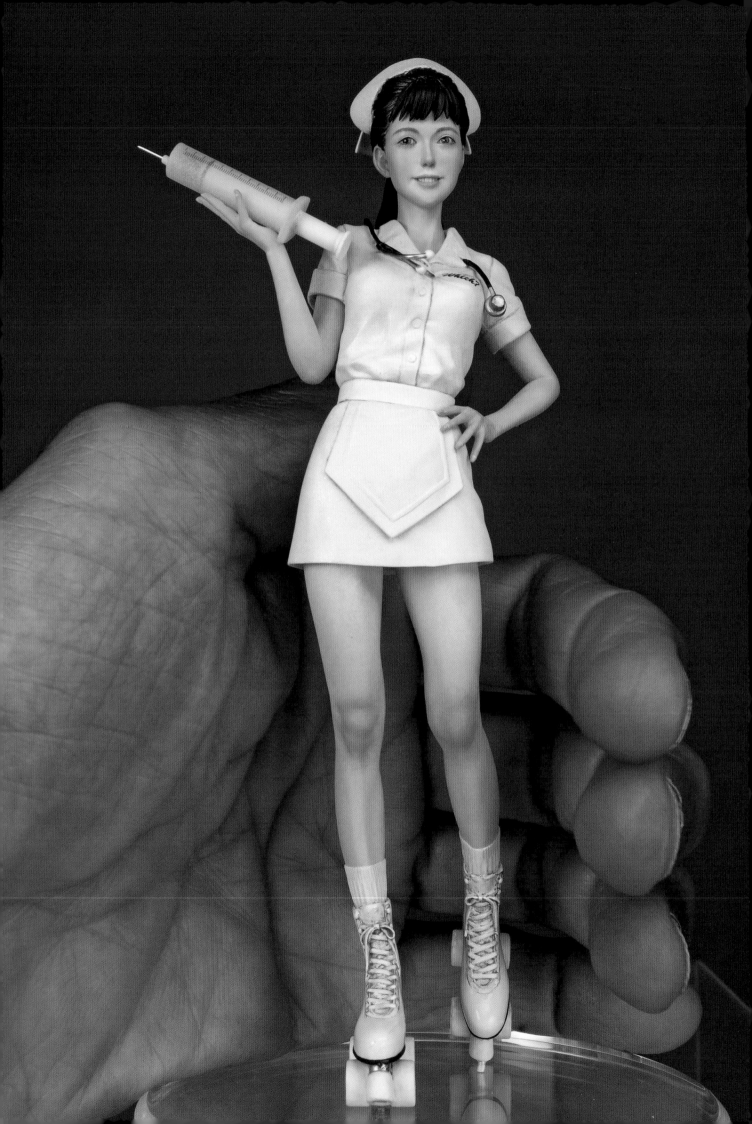

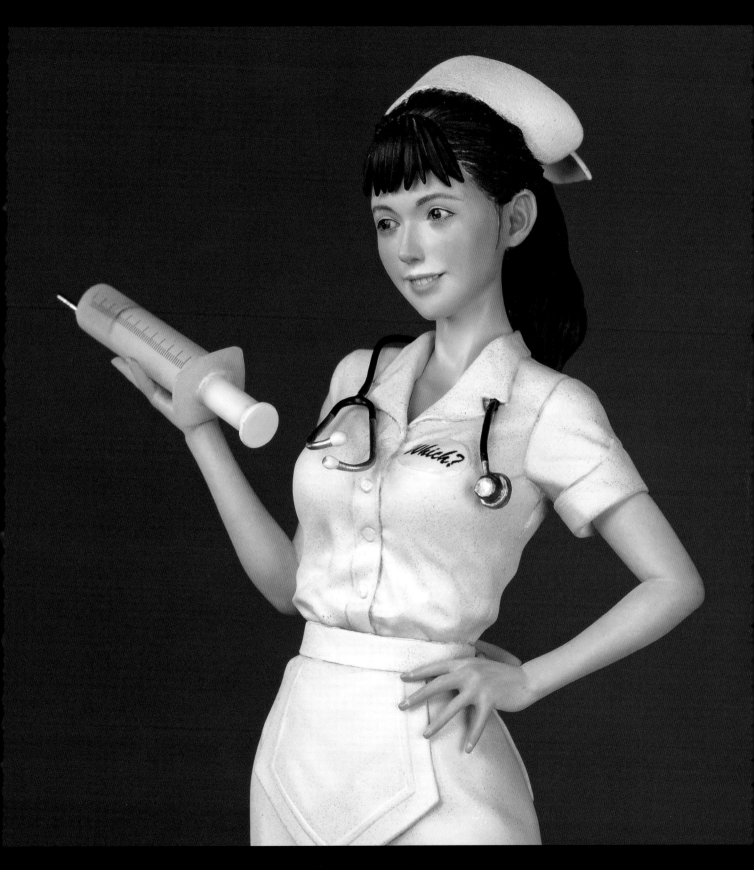

whichi-03（滑輪護士造型）
whichi 03 Roller nurse

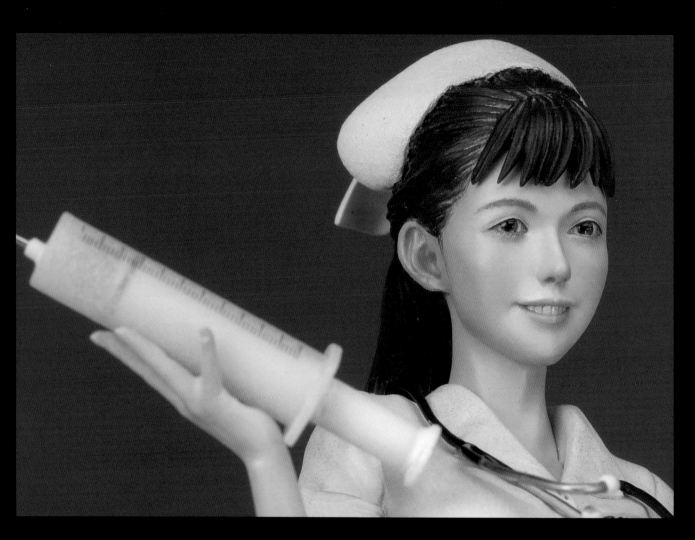

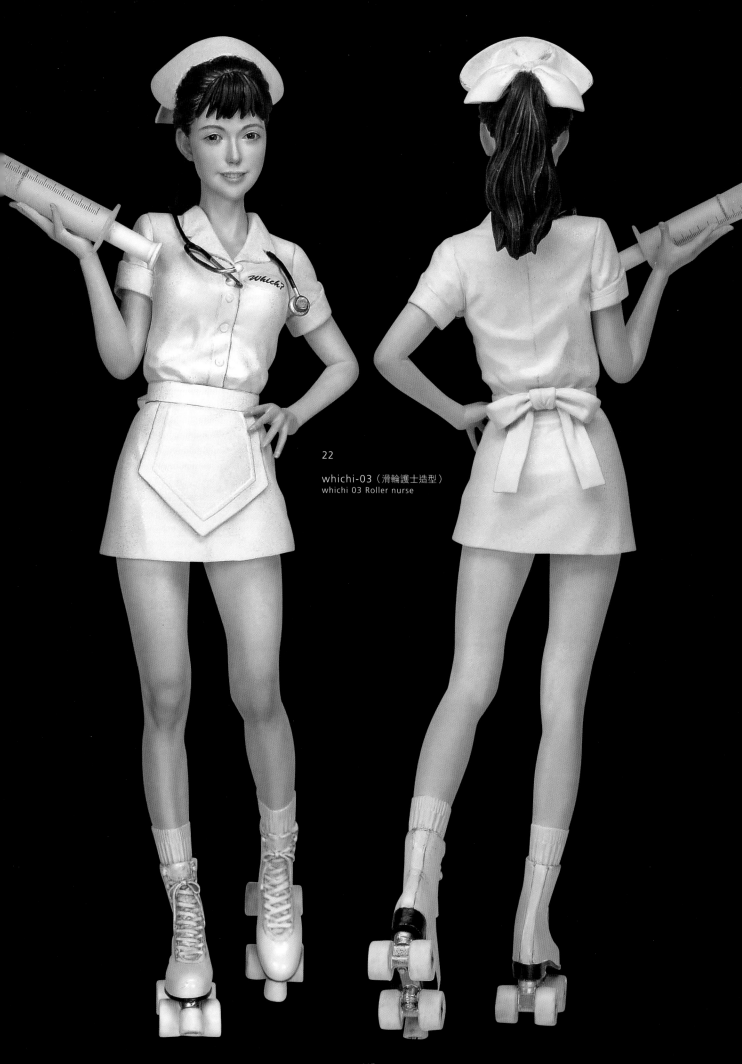

22
whichi-03（滑輪護士造型）
whichi 03 Roller nurse

田川弘&林浩己

Horoshi Tagawa x Hiroki Hayashi

田川弘因為林浩己的原型作品而開啟了人物模型的塗裝之路，當我們向他問道至今是否仍深受影響，他笑著回答其實並沒有。剛開始塗裝作品時，田川弘就帶有強烈的個人意見，甚至會向本人直接表達自己的風格和創作方向，而且至今從未改變。大家在前一本著作「PYGMALION令人心醉惑溺的女性人物模型塗裝技法」，從田川弘和林浩己對談的篇幅中就可看到完整的訪談內容，當問到對於林浩己的作品印象，田川弘的回覆是宛若田宮塑膠模型。他認為作品本身就已經充滿魅力，然而透過塗裝更能展現原型作品的優點，也就是塗裝表現上存有很大的空間與可能性。田川弘分析道，或許這是因為作品中表現了林浩己「內斂低調」的個性，因此讓人感到有些樸實，所以自己才想為作品添加色彩。如果經過自己塗裝，就可以突顯作品的美麗，這個想法引起他塗裝的興趣。這些話聽在他人耳中，似乎對林浩己有些失禮，然而對原型抱持「純粹毫無虛假的真心」，認真看待並且完成塗裝，正是田川弘對林浩己最高的讚譽。

Considering the fact that Kouki Hayashi's sculptures inspired Tagawa to start painting figures, you would think that Hayashi still carries a significant influence on him. However, Tagawa says otherwise. When Tagawa first started painting Hayashi's figures, he even went as far as directly asking Hayashi's opinion about the styles and direction of his works. In essence, his strong attachment towards Hayashi has not changed over the years. When asked about his impressions of Hayashi's sculptures, Tagawa replied that they remind him of Tamiya's plastic models. Hayashi's sculptures are attractive enough, but there is a lot of room for enhancement by painting them with colors. Tagawa believes this might be partly due to Hayashi's modest personality. Hayashi's sculptures may seem a little plain at first glance, but that is what motivates Tagawa to add something special to them. This may sound like a rude thing to say, but it's quite the contrary and is Tagawa's greatest compliment to Hayashi's sculptures. It is Tagawa's way of thanking Hayashi by facing his sculptures with a pure and honest heart.

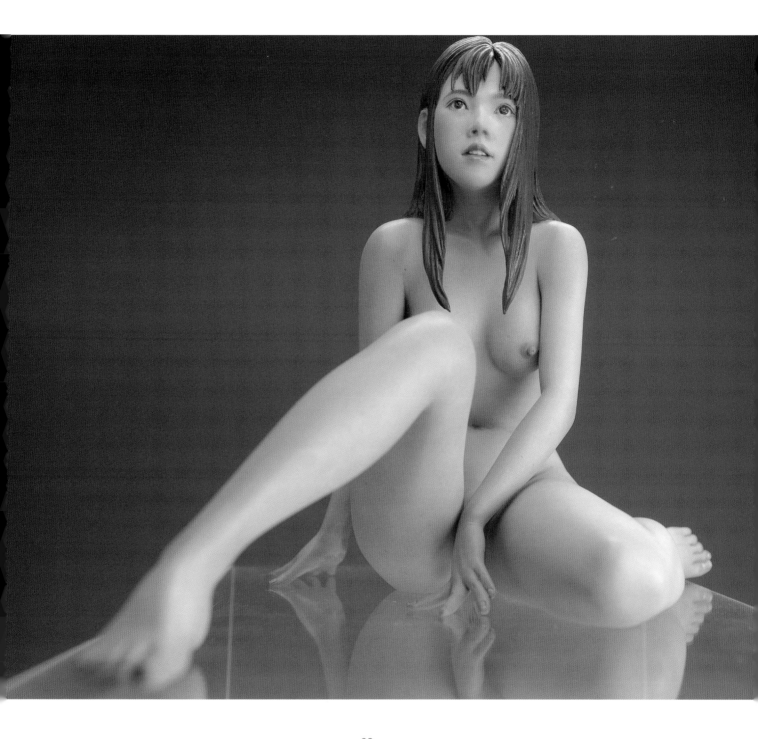

23

WJ-607 2 號機
WJ-607 02

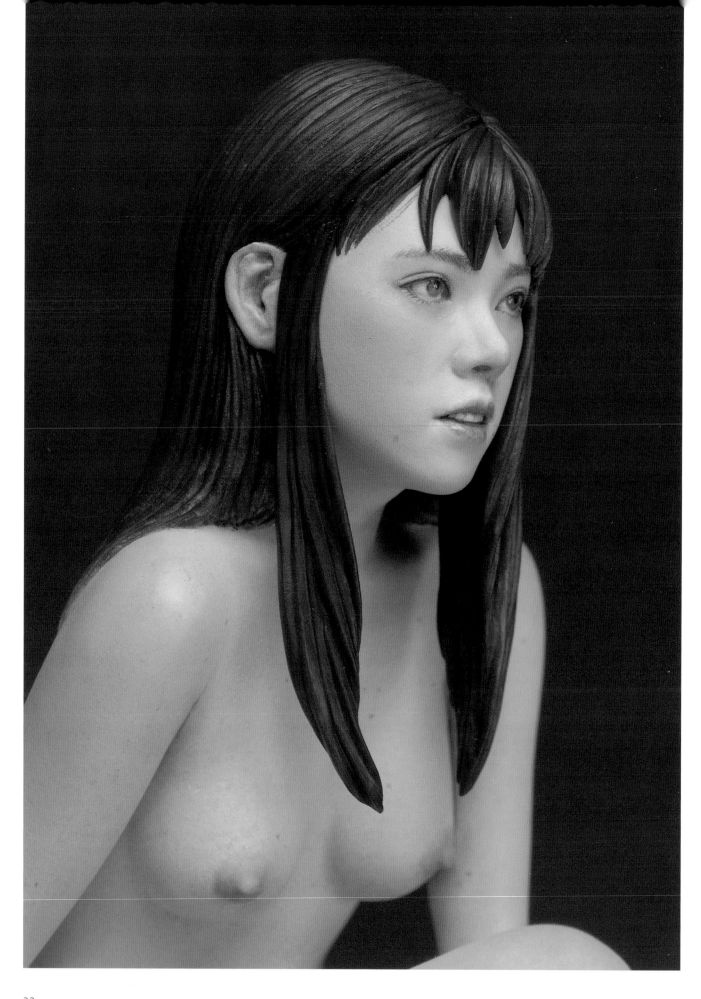

23

WJ-607 2 號機
WJ-607 02

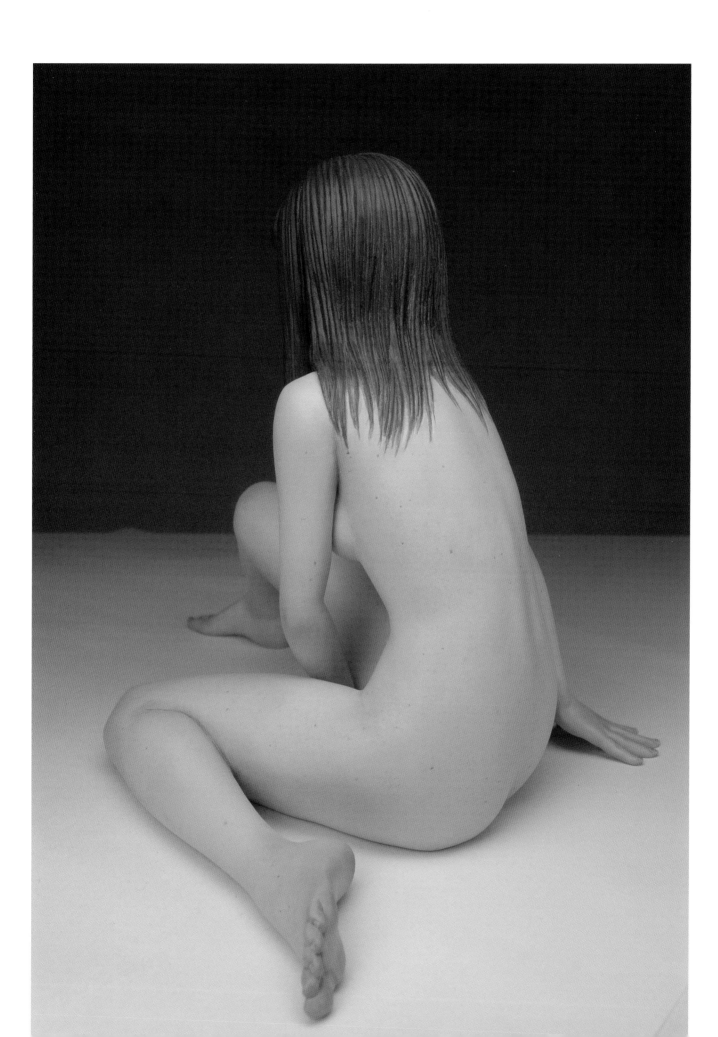

23

WJ-607 2 號機
WJ-607 02

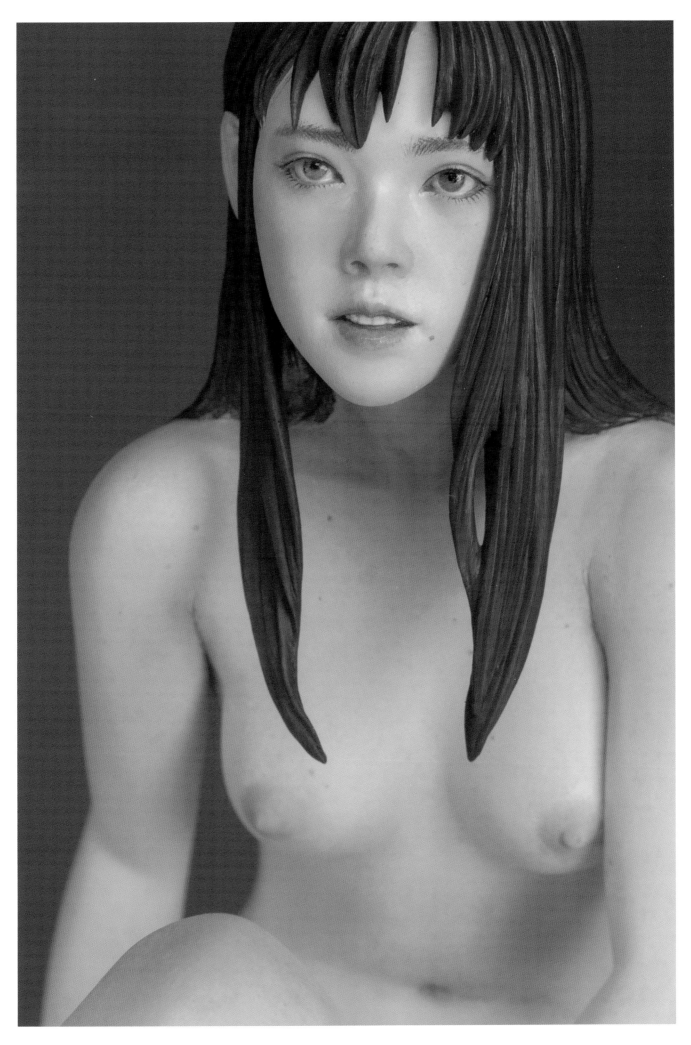

「超越偏愛」
What Lies Beyond

看到田川先生的作品讓我感到不可思議。

那些人物模型的眼睛雖小卻充滿力量，當我看進那雙眼睛時，並不能和她們眼神交會。

但是那雙眼睛絕對正看著「某處」。

這讓我驚訝不已。

他將時間、記憶，甚至情感，可以想到的一切都奉獻給她們，但是她們的眼睛卻看不到任何人，甚至是他。

我在其中感受到田川先生的內心。

而她們以不同於愛的形式回應賦予她們生命的恩人。

那就是她們「持續生存」在屬於她們的世界。

她們眼睛所見的既不是賦予生命的創作者，更不是觀眾，而是圍繞著她們的實際世界、景色、聲音，還有光線、命運。

我們任何人都不在其中。她們如同電影主角般，並未感覺到觀眾的存在而度過一生。

我認為他付出的愛實際上已得到回應。

因為對她們來說，這就是她們回應愛的方式。

There's just something special about Mr.Tagawa's works. I can't help but notice a strange phenomenon whenever I come across figures painted by him. When I look into those small but vigorous eyes, I can never seem to make eye contact with any of the girls. That's when it hit me. Tagawa's figures, which he devotes an incredible amount of time and effort into painting, are not looking at anyone, not even at him. That is precisely what makes his works unique. These figures repay their creator, Tagawa, not by recognizing our world but by living in their own universe. To some people, they may seem like nothing more than beautifully finished resin sculptures, but these girls certainly are "alive" in their world. Tagawa's creations see neither their creator nor the audience but the very real world they exist in. Their eyes capture the scenery, the sound, the light, and the destiny which lies within their universe. None of us exist in their sacred world. These figures, fleeting as it may sound, live their life unaware of the existence of an audience just as the protagonist in a movie. This is most definitely the single most significant accomplishment one can achieve as an artist, a painter, and a creator.

植田明志
Akishi Ueda

Profile

1991年出生於三重縣，為造型創作家。自幼深受美術、音樂和電影的薰陶，以普普超現實主義為主軸，創作出各種風格和主題，包括可愛甚至奇幻的巨大生物。田川弘也有收藏植田明志的作品，兩人交情至深。

Born 1991 in Mie-prefecture, Japan. Sculpture artist. Ueda has been deeply influenced by art, music, and movies since he was a child. He expresses himself through various mediums in a unique style. Tagawa's motifs vary from cute characters to strange gigantic creatures, with pop surrealism as his main attribute. Tagawa is a close friend of Ueda, owning some of his works.

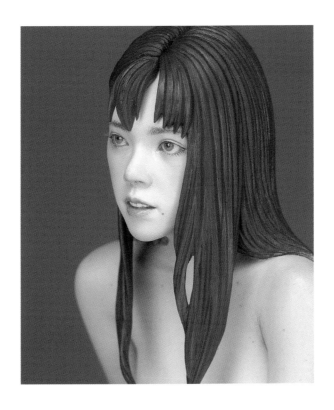

後記
Final Notes

簡單來説，人物模型原型師和塗裝師的關係就如同音樂創作的作曲家和演奏家。作曲家從無到有譜出樂曲，也就是原型師，而依照樂譜演奏或以爵士樂的形式即興改編，不但沒有失去樂曲的本質，更添加了屬於自我風格的旋律，「拓展了樂曲的世界」而樂在其中的正是演奏家，也就是塗裝師。從無到有的基礎創作者，和將基礎拓展為兩倍、十倍甚至千倍的人，兩者並沒有孰優孰劣之分，他們同樣是創造出樂曲的人，只是表現的形式不同。

田川弘以繪畫為職志，不斷練習素描追求正確掌握物件的形體卻遭遇瓶頸。在這段期間他接觸了人物模型，感受到其存在的魅力，即便不精準正確依舊充滿了原型師的想法。他開始沉醉於塗裝作品的創作，透過他獨特的筆觸描繪，創作出可感受人物模型生活的世界與氛圍。你是否可承受他如此豐沛的情感？

One can compare the relationship between a figure sculptor and a figure painter (commonly known as "finisher" in Japan) to that of a music composer and a performer. A composer who creates music from scratch is equal to a sculptor. A performer expands upon original music by putting their thoughts on the melody, whether according to the score or arranged like jazz. What performers do is, in essence, is very close to what figure painters do. They both output their interpretations of originals, and the only difference is in the method of expression.

Tagawa pursued a career in painting, and in that pursuit of accuracy, he ran into a wall. In the midst of all this, Tagawa came across figure painting. Figure sculptures, full of sculptors' thoughts and emotions, introduced Tagawa to a whole new world of artform. He became obsessed with the idea of creating art in which the viewers could even "feel" the atmosphere and picture the world in which his figures lived. A world of fictional images, yet filled with emotions, which could only be created with Tagawa's brush strokes.

Commentary

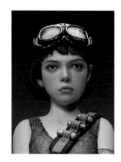

06　Black Rock City

無比例　原型：大畠雅人

大畠雅人的原型作品中，我最喜歡這個人物模型的表情。有裂痕的護目鏡、滲血的繃帶、不屈服的倔強表情看向何方？（2017年製作、個人收藏）

Of all Masato Ohata's sculptures, I like this girl's face the most. Her cracked goggles and blood-soaked bandages tell a lot of backstories.

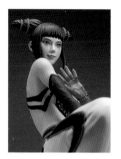

01　韓蛛俐

1/8比例　原型：林浩己

塗裝時並沒有太跳脫角色設定，在保有原有設定之下呈現自我風格，而且還稍加改造，連原型師也看不出來。（2018年製作、個人收藏）

I tried my best not to deviate too much from the original character's setting but still gave it my touch with minor modifications.

© CAPCOM CO., LTD. ALL RIGHTS RESERVED.

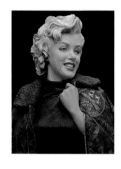

07　"Bye Bye Baby" Marilyn Monroe in Korea

1/10比例　原型：Sang-Eon Lee

通常歷史人物模型連刺繡補丁也會用筆塗，但我刻意打破常規使用印花貼紙修飾。衣服的質感也成了欣賞的亮點。（2015年製作、個人收藏）

Historical figures are usually entirely painted with brushes, but I ended up using a decal for her flight jacket's patch.

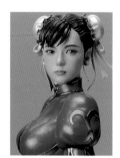

02　春麗

1/8比例　原型：林 浩己

我多次接到海外春麗粉絲的抗議表示：「大腿太細了！」（笑）。作品特色之一是表情會隨著製作當時而有些微的差異。（2019年製作、個人收藏）

Overseas Chun-Li fans have often scolded me that the figure's thighs were too thin, making me giggle a lot.

© CAPCOM CO., LTD. ALL RIGHTS RESERVED.

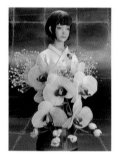

08　eri artwork 『紙飛機的去向』

無比例　原型：小抹香ke

人物模型止不住的淚水沿著臉頰流至唇邊，用花瓣掩飾隱忍慟哭的表情。這也是我第一個邊流淚邊塗裝臉部的作品。（2014年製作、個人收藏）

Tears flowing down her cheeks and her tightly closed lips...... she was the first figure I painted while crying myself.

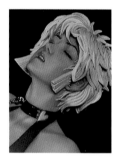

03　甜心戰士　空山基版

1/4比例　原型：圓句昭浩

改造了大拇指部分的繩帶，使大拇指露出，增加了身體露出的部分，使人物模型更加性感。尺寸較大，所以塗裝的作業較吃重繁瑣。（2004年製作、個人收藏）

I modified and cut out the thumb section of her gloves, exposing more skin to accentuate her sexiness.

©永井豪/ダイナミック企画　創作造形：造形村/ボークス

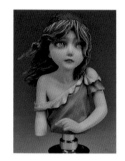

09　珂賽特

無比例　原型：もでらーT

她是19世紀著名小說的封面插畫主題，塗裝上為了讓沾有污垢的頭髮衣服和水潤的肌膚質感形成對比，著實費了一番功夫。（2014年製作、個人收藏）

This figure was inspired by 19th. century's famous book illustrationl, and I had difficulty expressing the difference between her dirty attire and pure skin.

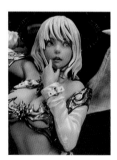

04　惡魔娘篠崎

1/6比例　原型：小抹香ke

作品的魅力在於誇張的姿勢和娃娃臉的對比。對於形象的設定並不是非人類，而只是平凡的女孩長出翅膀和角。（2017年製作、個人收藏）

I don't see her as a monster or some mythical creature, just an ordinary young girl with wings and horns.

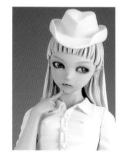

10　KONNY

1/6比例　原型：klondike

只有這個女孩頭戴寬邊高頂帽，成了四人並排時注目的焦點，也是我個人很滿意的造型。（2017年製作、個人收藏）

I converted her hat into a garrison cap, which gave her some uniqueness when lined up with her three companions.

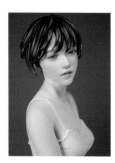

05　PB-01

1/6比例　原型：Daco

明明就是擬真類的人物模型，卻還原了如動漫作品般的「小碎髮」還面帶微笑。表情沒有太多複雜的情緒，充滿魅力。（2020年製作、個人收藏）

This one has a unique combination of realism and fictional characterism. Her charm is in her mixed facial expression.

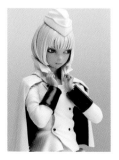

11　ERDE

1/6比例　原型：klondike

這是在個展中，以四人為一組的展出作品。這個人物模型的特色是披風造型，組裝時費了一些功夫才呈現出俐落的線條。（2017年製作、個人收藏）

She was one of four figures I painted for my solo exhibition. Her distinctive cloak proved to be quite difficult to achieve a perfect fit.

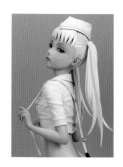

12　SOIL
1/6比例　原型：klondike

個展中將整個會場統一成白色。我讓這四個女孩代表個展的主視覺焦點。這個女孩身穿改造後的吊帶服裝，是我很自豪的孫女（笑）。（2017年製作、個人收藏）

For the exhibition, the entire venue was unified in white color. So, these four girls played a central role as the icons of the exhibition.

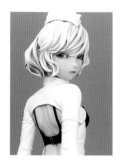

13　LUCE
1/6比例　原型：klondike

LUCE是四人中唯一以背後視角呈現回眸姿勢的人物模型，其實這是klondike原型套件中我最喜歡的女孩。（2017年製作、個人收藏）

Out of four girls, Luce was the only one posing backward. To tell you the truth, she is my favorite girl out of all klondike's figures.

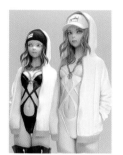

14　WAKKER
1/5比例　原型：klondike

單色調似乎很適合這兩個人物模型，又能展現彼此的個性。我將其中一位的棒球帽改為針織帽。我在塗裝時自行將她們設定為雙胞胎，為兩人一組的作品。（2018年製作、個人收藏）

White and black, monotone was the perfect theme for these two figures. Each has its own personality, yet they are inseparable.

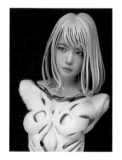

15　HB01
無比例　原型：K

K的原型作品中，人物模型都有張可愛的臉，但是就我所知，其他的套件中沒有比這個人物模型還可愛的臉。（2021年製作、個人收藏）

ke's figures are known for their cuteness, but I have yet to come across a garage-kit sculpture with a face cuter than this one!

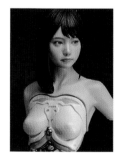

16　Android EL
1/6比例　原型：K

因為是3D列印的套件，每個零件的嵌合部位都完美相接，沒有改造的空間，不過組裝時有點費工。（2019年製作、個人收藏）

Since this was a 3D printed kit, the fit of each joint was so perfect that it made the assembly process a bit of a challenge.

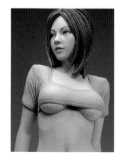

17　WJ-612（暗殺者造型）
1/6比例　原型：林 浩己

人物模型改造的作品中大多會脫去人物的衣服，或許受到自己腦中設定的故事影響，我通常偏好讓人物穿上衣服。（2016年製作、個人收藏）

When it comes to female figures, I see a lot of sculptures with subjects undressed. I prefer them with some clothing on.

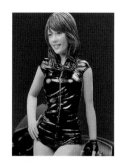

18　HQ-12-02（暗殺者造型）
1/12比例　原型：林 浩己

在拿到套件時，我覺得左手的姿勢有點不自然而試圖改造，幸好辛苦改造呈現不錯的效果，讓人物模型的形象更立體豐富。（2015年製作、個人收藏）

When I first assembled this kit, her left hand felt a little odd. I painstakingly took care of the issue, which paid off in the end.

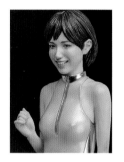

19　HQ-12-05
1/12比例　原型：林 浩己

這個人物模型我處理過非常多次。從指尖就可感受到姿態散發的可愛氣息，後來才知道原來是原型師依照喜歡的人所製作的人物模型……。（2018年製作、個人收藏）

I've painted this figure multiple times in the past. I heard that she is based on a particular individual Mr.Hayashi fancies.

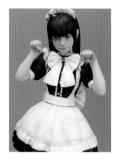

20　which-01
1/12比例　原型：林 浩己

Which？系列第一彈。我竭盡所能地表現出完整的形象氛圍，所以在塗裝時，還特地前往女僕咖啡廳，而且是生平第一次。（2019年製作、個人收藏）

I must confess that I went to a maid cafe for the first time in my life before painting her. Of course, this visit was purely for research.

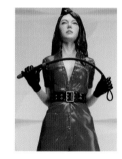

21　which-02
1/12比例　原型：林 浩己

這個原本是商品樣本的塗裝委託，但我還加以改造讓她穿上靴子，結果受到原型師嚴重的抗議……。（2020年製作、個人收藏）

This was intended to be a painted sample for Mr.Hayashi's figure kit, but I ended up modifying it and put boots on her.

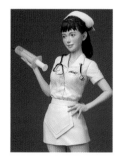

22　which-03（滑輪護士造型）
1/12比例　原型：林 浩己

提到護士就不得不提到針筒，而讓人物手拿超大針筒，結果大家都說這是「灌腸」，讓我感到很氣餒。（2021年製作、個人收藏）

She is holding a large syringe as a symbol of a nurse. It's pretty depressing that everyone thought she had an enema in her hand.

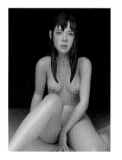

23　WJ-607
1/6比例　原型：林 浩己

塗裝林浩己的原型作品已過了1/4世紀之久，在我的記憶中，這應該是林浩己第一個製作小胸部的人物模型套件。（2020年製作、個人收藏）

I have been painting Mr.Hayashi's sculptures for more than 25 years, but this one must be his first sculpture with small breasts!

※ 作品介紹頁面的「號機」標示是指田川弘製作的順序，「1號機」代表第一個作品。

對 虛 像 的 偏 愛

田 川 弘 ＰＹＧＭＡＬＩＯＮ 女 性 人 物 模 型 作 品 集

對虛像的偏愛
田川弘 PYGMALION 女性人物模型作品集

作　　　者　田川 弘
翻　　　譯　黃姿頤
發 行 人　陳偉祥
出　　　版　北星圖書事業股份有限公司
地　　　址　234 新北市永和區中正路 462 號 B1
電　　　話　886-2-29229000
傳　　　真　886-2-29229041
網　　　址　www.nsbooks.com.tw
E－M A I L　nsbook@nsbooks.com.tw
劃 撥 帳 戶　北星文化事業有限公司
劃 撥 帳 號　50042987
出 版 日　2022 年 9 月
I S B N　978-626-7062-28-9
定　　　價　680 元

如有缺頁或裝訂錯誤，請寄回更換。

國家圖書館出版品預行編目 (CIP) 資料

對虛像的偏愛 : 田川弘 PYGMALION 女性人物模
型作品集 / 田川弘作 ; 黃姿頤翻譯 . -- 新北市 : 北
星圖書事業股份有限公司 , 2022.09
128 面 ; 21.7x29.7 公分
ISBN 978-626-7062-28-9（精裝）

1.CST: 模型　2.CST: 工藝美術　3.CST: 作品集

999　　　　　　　　111008533

特別感謝

株式會社CAPCOM
DYNAMIC企劃株式會社
造形村／ARTBOX
井上純一
植田明志
林 浩己
klondike
Daco
Modeller_T
小抹香ke
大畠雅人
K
Sang-Eon Lee
KITA
凌元臻
eri（silent letter）
圓句昭浩
omachan
堀 和貴（ARTBOX）
（排名不分先後並省略敬稱）

官方網站　　　臉書粉絲專頁　　LINE 官方帳號